Drawing systems

The problem of representing three-dimensional
space has always intrigued and taxed artists and
designers. All those whose language is partly or
wholly visual, whether engineers, architects,
industrial designers, cartographers, painters or
sculptors, tend to use drawing systems traditional
to their field, often without considering how
appropriate they may be to a particular problem.
Changes in the mechanics of visual presentation
through photography and the computer call for
a critical re-examination of the various systems
of notating form and space.

Fred Dubery and John Willats present and define
all the common drawing systems — perceptual,
conceptual and mixed systems — and describe
how they have been used by such artists as
Vermeer, Rowlandson, Caravaggio, Juan Gris,
Hockney, etc. *Drawing Systems* provides those
who need to describe three-dimensional space
with a thorough understanding of each system
and therefore a wider choice of method.

Fred Dubery's paintings are frequently exhibited
in London galleries and he has had two one-man
shows at the Trafford Gallery. Trained at the
Royal College of Art, he is a visiting tutor at the
Royal Academy Schools and, together with John
Willats, teaches in the Fine Art Department at
the North-East London Polytechnic. John Willats
read engineering at the University of Cambridge
where he was awarded a prize for his engineering
drawings. He then trained as a sculptor at the
Royal College of Art where he gained the
College drawing prize. His life-size 'Politician'
was shown at the exhibition 'Play Orbit' at the
Institute of Contemporary Arts, London.

Drawing systems

Fred Dubery and John Willats

Studio Vista: London
Van Nostrand Reinhold Company:
New York

A Studio Vista/Van Nostrand Reinhold Paperback
Edited by John Lewis
© Fred Dubery and John Willats 1972
Published in London by Studio Vista
Blue Star House, Highgate Hill, London N19
and in New York by Van Nostrand Reinhold Publishing
Company, a Division of Litton Educational
Publishing, Inc.
450 West 33 Street, New York, NY 10001
Library of Congress Catalog Card Number: 78 183901
Set in 9 didot on 12 pt Univers 689
Printed and bound in Holland
by Drukkerij Reclame N.V., Rotterdam
ISBN 0 289 70139 2 (paperback)
 0 289 70140 6 (hardback)

Contents

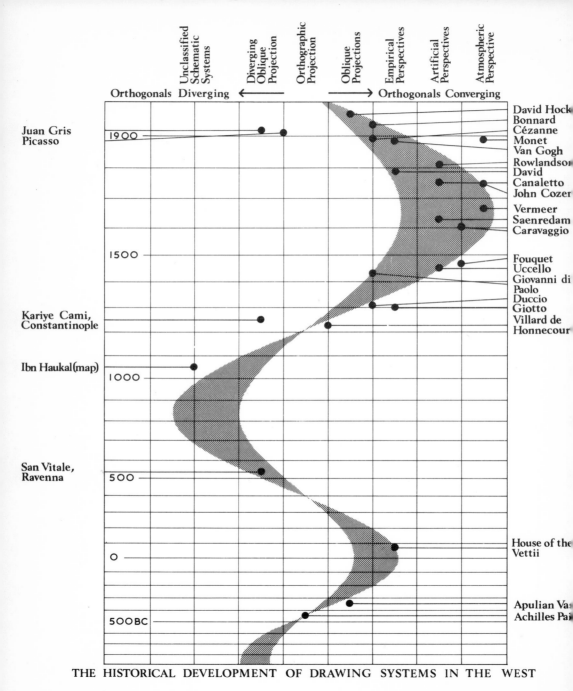

Unclassified Schematic Systems
Diverging Oblique Projection
Orthographic Projection
Oblique Projections
Empirical Perspectives
Artificial Perspectives
Atmospheric Perspective

Orthogonals Diverging ← → Orthogonals Converging

Juan Gris
Picasso

1900

David Hock
Bonnard
Cézanne
Monet
Van Gogh
Rowlandson
David
Canaletto
John Cozer

Vermeer
Saenredam
Caravaggio

1500

Fouquet
Uccello
Giovanni di
Paolo
Duccio
Giotto
Villard de
Honnecour

Kariye Cami,
Constantinople

Ibn Haukal(map)

1000

San Vitale,
Ravenna

500

House of the
Vettii

0

Apulian Va
Achilles Pai

500BC

THE HISTORICAL DEVELOPMENT OF DRAWING SYSTEMS IN THE WEST

6

lents in the fields of engineering, architecture, strial design, cartography, painting and oture — that is, fields whose language is y or wholly visual — are inclined to use ring systems traditional to those fields, out considering how appropriate they may be particular problem. The great changes which e occurred in these fields, together with nges in the mechanics of visual presentation ugh photography and the computer, seem to for a critical re-examination of the utility of various drawing systems. Our aim in writing book has been to present and define all the mon drawing systems in the hope that ents in all fields who need to describe e-dimensional space and objects within it have a greater range of choice.

recise definitions of most of the conceptual ving systems already exist in the fields of neering and cartography. Bunge[1] has :ribed the traverse from mathematical descrip- s of space, through the various systems of graphy and cartography to perceptual optical) systems. Traditionally, art historians e concerned themselves with describing tings in terms of artificial perspective, but recently Gioseffi[2] has pointed out the widespread use of oblique and orthographic projections.

Our intention has been to bring together all these ideas and to present them in a form which we hope will be of immediate and practical use to students, as well as to practising painters and designers.

In comparing these different examples it is impossible not to be struck by the apparent correlation between the use of a particular drawing system and the social or religious structure of the society from which the example is taken, and Panofsky[3] laid the foundations of a fruitful and growing school of art history based on this correlation as applied to perspective. While we have not stressed this approach, we have chosen examples which seem to lend weight to the consideration that this correlation may be extended to all methods of describing space, and that all drawing systems may be regarded, psychologically, as symbolic forms.

Two or more drawing systems are sometimes used together within the same composition. This can happen deliberately, or through the collision between two different types of cultures. Chapter 7 is concerned with these mixed systems.

1. William Bunge *Theoretical Geography,*
 C. W. K. Gleerup, Lund, Sweden.
2. Decio Gioseffi *Encyclopedia of World Art,*
 Magraw-Hill Book Co. New York, Toronto, London;
 vol. XI *Perspective* p. 183 ff.
3. E. Panofsky *Die Perspektive als Symbolische Form,*
 Vortrage der Bib. Warburg 1924—25, pp. 258—330.

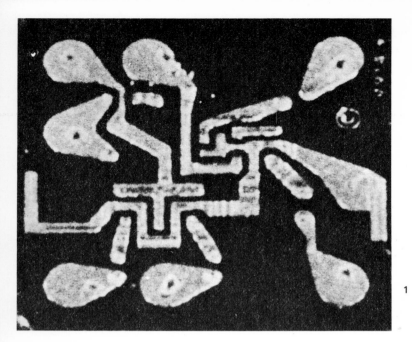

1 Logic circuit from a computer (micrologic chip), *c.* 1967, 0.03 × 0.03 in. (0.08 × 0.08 cm.)

2 Ibn Haukal, a map of the Mediterranean, *c.* eleventh century AD

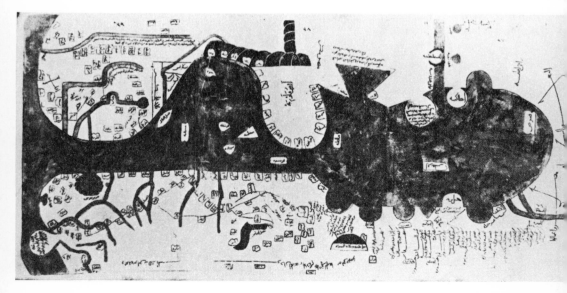

ematic systems

have chosen in this book to deal mainly
n drawings made by one or other of the
ple projection systems. This leaves out of
ount the large field of schematic systems;
wings made from objects by some process of
traction, rather than by geometry.

here have been at various times religious
hibitions of the representation of the visual
rld, or at least of the human figure. The
ond commandment forbids representation of
kind, and an attempt was made to enforce
by the iconoclasts in the Byzantine Empire
ing the eighth and ninth centuries AD.
resentation has always been forbidden by
m. Drawing in these periods has of necessity
n schematic.

More recently the attempt to describe scientific
ndustrial processes has resulted in a whole
v area of schematic drawings. The first
wings of electrical apparatus were descriptive,
botanical drawings, designed to please the
as well as to impart information. Gradually
se drawings became more abstract until
ally the drawings described not the apparatus,
the movement of electricity. Such examples
ld be multiplied almost indefinitely: graphs,
w-charts, 'life' games[1], all illustrate processes
movements rather than objects. With the
ention of printed circuits the drawing and the
ect became consubstantial. The logic circuit
a computer (fig. 1) is at once a drawing of the
ic and the electric circuit by which the logic is
ected. Many modern artists have attempted
s same conjunction of object and image.

Maps have generally occupied the middle
ground between pictorial representation and
mathematical abstraction. The first of all projec-
tion systems was suggested by Ptolemy, the
great Alexandrian cartographer, in the second
century AD. The maps of the middle ages were
mainly schematic (fig. 2) or illustrated religious
dogma, but with the invention of the magnetic
compass in the tenth century AD, and use of
rumb lines (lines showing compass directions),
map-making became more scientific and more
descriptive.

During the sixteenth century, the development
of map-making formed a part of the development
of drawing systems generally. Dürer was closely
associated with the great cartographic houses of
Nuremburg, and engraved a map of the world in
globular projection (a form of perspective).[2]
Bruegel was a member of the Humanist circle
which included the great Flemish map-maker,
Abraham Ortelius, a contemporary and fellow
countryman of Geradus Mercator.

Modern cartography has become progressively
more mathematical, i.e. schematic. With our
present ability to extract, store and process
information by computer, together with the
collection of information by stero-photography,
map transformations seem to open up new
possibilities in schematic drawing.

1. Martin Gardner 'Mathematical Games', *Scientific American,* Feb. 1971, vol. 224, no. 2, p. 112 ff.

2. Leo Bagrow *History of Cartography.* C. A. Watts & Co. Ltd, London, 1964.

Projection systems

Any projection system depends on the idea of straight projection lines running from points on an object to corresponding points on a flat surface. The type of projection system depends on the relationship of these lines to each other: whether they diverge, converge, or run parallel, and the angle at which they strike the surface.

Orthographic projection

In the simplest case, these lines are parallel, and strike the surface at right angles. The setting sun directly facing a flat wall, will throw shadows on to it which are the same size and shape as the objects they represent; the sun is so far away that its rays are very nearly parallel. These shadows are orthographic projections.

The first use of the system was in the cave paintings of the Old Stone Age, notably those at Altamira and Lascaux, produced by a loosely organized, free-wheeling, hunting society. With the end of the last period of glaciation, the climate changed and the people of the New Stone Age began to depend on agriculture rather than hunting for their survival. The need for a calendar and the desire to pass on essential information prompted a much more abstract and schematic art, and it was not until the establishment of the rich and stable societies of Egypt and Mesopotamia that the representation of real objects in orthographic projection was revived in the form of wall paintings and shallow relief sculpture. In Greek vase painting this method was continued; from the vases of the geometric period until the middle of the fifth century BC

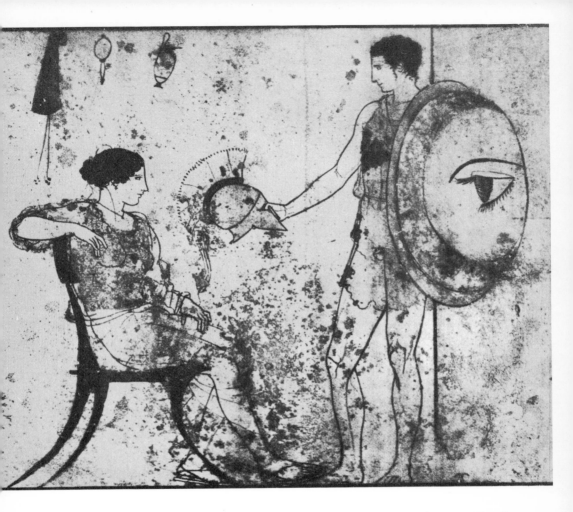

Achilles painter *Leavetaking,* middle of the fifth century BC. From a tomb *lekythos,* National Museum, Athens

all objects were described in terms of orthographic projection. The only development was the increasing skill with which the objects were described, and, after the sixth century BC, the invention of foreshortening.

In the drawing *Leavetaking* (fig. 3), taken from a funeral *lekythos,* the use of the system is very strict, and the foreshortening is delicately and exactly controlled. The choice of orthographic projection means that the objects appear as

themselves without reference to a spectator, or, since the projection lines are parallel, as if the spectator is an infinite distance away. Also, orthographic projection in this simple, single-view form, cannot be used to describe objects in real space, except to the very limited extent implied by the foreshortening. In Greek vase painting generally the connection between objects is achieved only by the composition on the surface. Earlier vase paintings were made entirely on surfaces which curved in two directions, so that the use of orthographic projection could only be approximate. In some of the later vases, like this *lekythos,* the painting was made on a surface which was almost a perfect cylinder, so that a stricter projection system could be used. In this particular vase the painting is confined to a small part of the cylinder, so that the whole scene can be viewed from one position; it was only a short step to easel painting on a flat surface.

Painting on to a flat surface provides the opportunity of composition in depth, and after the middle of the fifth century BC, what little evidence we have suggests that painters attempted to solve two different problems; a further development of foreshortening, and the depiction of space through the first attempts at oblique projection, leading eventually to the empirical perspective of the Roman period. After the fourth century, the use of orthographic projection, except for figures, was almost abandoned.

We have already mentioned that a single orthographic view of an object is insufficient to describe its position in space; but three related views will define it completely and from these views other auxiliary views can be obtained, if necessary in perspective or some other system. From drawings by Uccello and Dürer it is clear that this principle was understood during the early Renaissance. Implicitly, it underlies Alber *construxione legitimi,* and a system of related plan and elevations must have been in use for architectural drawings at least after the time of Brunelleschi. The understanding of this princip is at least as important as the discovery of scientific perspective, which logically it must precede.

However, it was not until the beginning of t eighteenth century that the full potential of the system was realized by Gaspard Monge, a French military engineer responsible for design fortifications. His method of projective geometr although at first on the French secret list, soon became the common language of engineering and architectural drawing in Europe, and he als standardized the relationship of plan, side and front views, in the form now known as 'first angle projection' (fig. 4a). In this method the object is imagined as being placed inside a box with three or more sides. Images of the object are projected back (like shadows) on to the sides of the box, which are then unfolded. This was a very necessary step, as the increasingly complex machines which developed with the industrial revolution, of which Brunel's block-making machinery (fig. 5) is typical, could not be described by the old oblique projections, or casually related orthographic views, without the drawings becoming hopelessly confused.

In America a similar method, 'third angle projection', was adopted (fig. 4b); but in this case the images are projected *forward* and the box is imagined to be transparent, so that the images appear on the outside. The relationship of object, image and picture plane is in this cas similar to that used in perspective drawings. When the box is unfolded the relationship of plan, side and front views is different from that obtained by first angle projection, but the basic

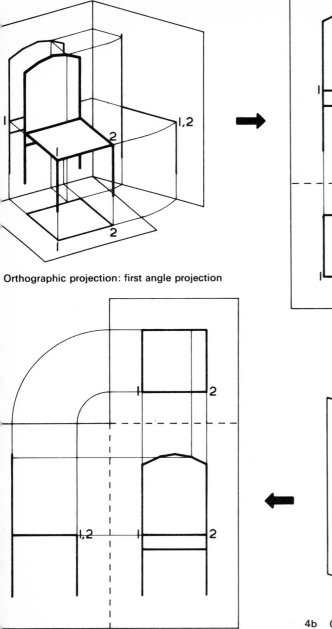

Orthographic projection: first angle projection

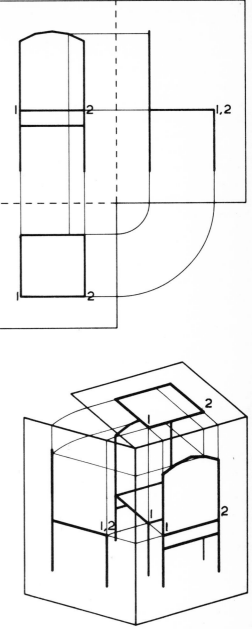

4b Orthographic projection: third angle projection

13

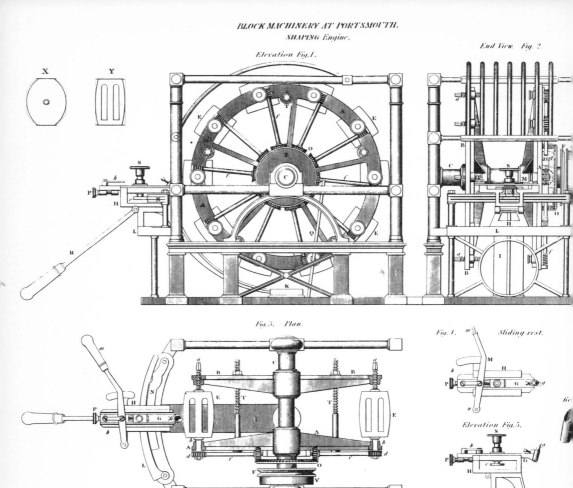

Fig.3. Plan.

Fig. 1. Sliding-rest.

Elevation Fig.5.

5 J. Farey *Block Machinery at Portsmouth* 1820.
Engraving from Ree's *Cyclopedia*

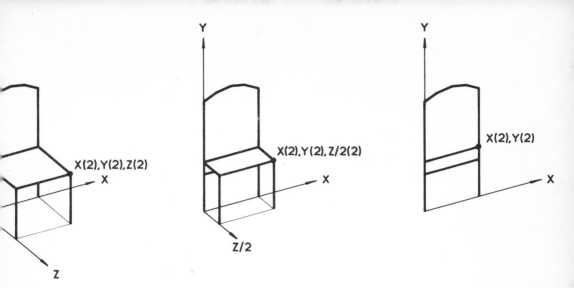

X(2),Y(2),Z(2)

X(2),Y(2),Z/2(2)

X(2),Y(2)

5b and 6c Cartesian co-ordinates. The drawing of a head is based on a sixth-century Greek stone carving. A surveyor's digitalizer was used to establish the position, in cartesian co-ordinates, of about 800 points on the surface of the carving. These points were transferred into trimetric projection using an IBM 1130 computer, and the drawing was obtained by joining up the points using a graph plotter. Our thanks are due to the Surveying Department and the Computing Services Department of the North-East London Polytechnic

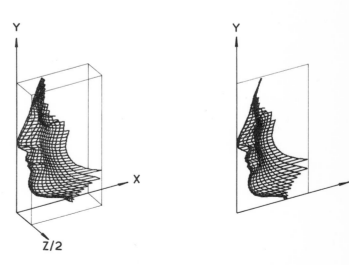

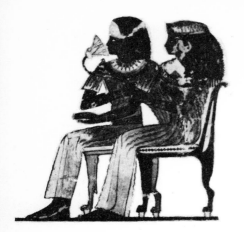

7 Painting of a banquet (detail), from Thebes. Egyptian, New Kingdom. British Museum

principle of projection by straight parallel lines is the same in each case.

It is also possible to think of the edges of th box as three axes, and to define each point on the object in relation to these axes by a set of Cartesian co-ordinates (fig. 6a). Instead of using a geometrical method, views of an objec may be obtained by algebraic manipulation of the co-ordinates. For example, if we divide all the Z co-ordinates by half, we shall obtain an object in shallow relief (fig. 6b). Notice that th technique can be applied to any drawing syste and is not necessarily associated with relief sculpture in perspective. A reduction of the Z co-ordinates to zero will result in an orthograp projection (fig. 6c). This method, previously o only theoretical interest, is of great importance particularly for complex objects, now that thes calculations can be carried out very rapidly by computer, and the views drawn out automatic by graph plotter, or displayed on a cathode ra tube.

Horizontal oblique projection

Two views of an object, side and front, added together, give a more complete description of object than either view alone. This extension c orthographic projection appeared first in Egyp wall painting (fig. 7), and then again, later, in Greek vase paintings after the middle of the fif century. The method is simple enough with rectilinear objects, like tables and chairs, but with more complex objects, such as four-hors chariots, a compromise must be made where t two views join.

It would seem inappropriate to dignify such rough and ready method into a system, but in it can be applied quite strictly. Using our previ illustration, if the rays of the setting sun strike wall obliquely, rather than at right angles, ther

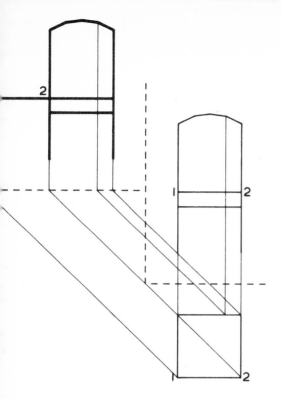

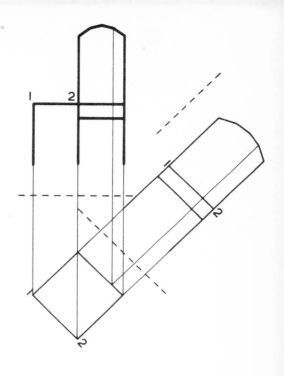

Horizontal oblique projection

Foreshortening in orthographic projection

the shadow of an object lying parallel to the wall will be elongated; and if the object is rectilinear, then the shadows of the side and front will appear tacked together (fig. 8a). A reference to the primary geometry is a useful way of distinguishing between this system which we will call 'horizontal oblique', and foreshortening in orthographic projection (fig. 8b) — a distinction which the Greeks themselves were not always capable of making. In their case the method was important not so much in itself, but as an intermediate step towards full oblique projection.

Nevertheless, the system has certain advantages of its own; it has been perhaps most

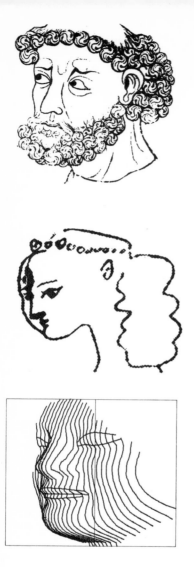

commonly used for portrait heads, where the and front views are of most importance, and top view of little consequence. A drawing by Villard de Honnecourt (fig. 9) shows how the head has been extended in an attempt to sho both these views at once. A similar elongation appears in many of Cranach's portraits. Perha the best known examples are found in some Picasso's portraits (fig. 10). We may compare these examples with a drawing of a head in s horizontal oblique projection obtained by usir a computer (fig. 11).

Another advantage of this system is that it suggest the solidity of objects, and yet allow composition to remain on the surface as a flat pattern; this is apparent in the picture of a mo tain village by Huang Kung-wang (fig. 12). Cézanne used a very similar basic compositio his well known series of paintings of Mont Sainte-Victoire. Because of his desire to imply space, and yet to retain the validity of the pict surface, Cézanne often made use of the spatia ambiguities inherent in horizontal oblique, although his use of the system is not always s clearly defined as in this example (fig. 13).

Another aspect of the system perhaps dese to be mentioned. The *Gestalt* psychologists, b whom Cézanne was influenced, thought that brain corrects the visual image to give us a picture 'in the mind's eye' which is closer to v we know of an object than to what we see.

9 Villard de Honnecourt, drawing of a man's hea from a sketchbook *c.* 1230. Princeton Universi

10 Head taken from a drawing by Picasso

11 Head in horizontal oblique projection, by comp

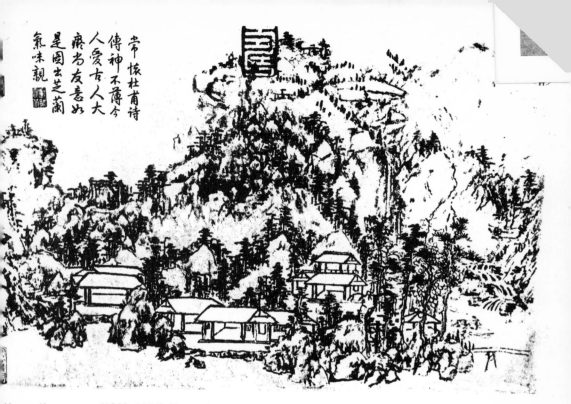

常恨杜甫诗
傳神不蒋今
人爱古人大
廳为友意如
是圃出芝蘭
氣味親

Huang Kung-wang (1269–1354) *Mountain Village*. Ink on paper. Formerly Yamamoto collection Tokyo, Japan

According to this argument, houses in horizontal oblique are much closer to what we 'really see' than they would have been if Cézanne had painted them in perspective. Whatever the truth of this argument may be, by concentrating on problems of perception, Cézanne arrived at a conceptual method of depicting space which was later taken up and developed by the Cubists.

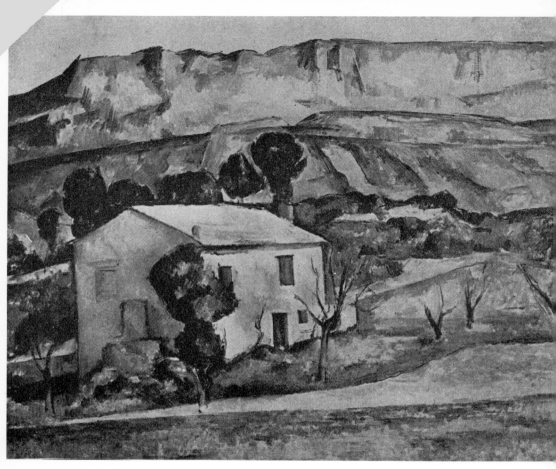

13 Paul Cézanne *La Sainte Victoire Beaureceuil*
1885/6. Oil on canvas 25³/₄ × 32 in. (65.4 × 81.3
cm.). Marie Harriman Gallery, New York

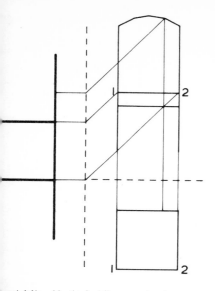

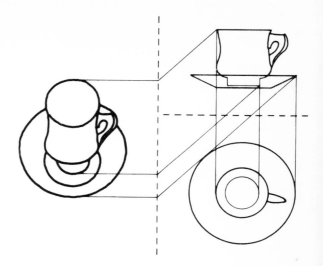

and 14b Vertical oblique projection

Vertical oblique projection

A vertical oblique projection is obtained empiri-
cally by adding top and front views together,
rather than side and front views as in horizontal
oblique. Vertical oblique projections may also be
obtained by projecting an image of the object
obliquely on to a picture plane (figs 14a and 14b).

Until this century, the use of vertical oblique
projection in the West was exceptional, and in
China it was rarely used except for the super-
imposition of mountains one above the other;

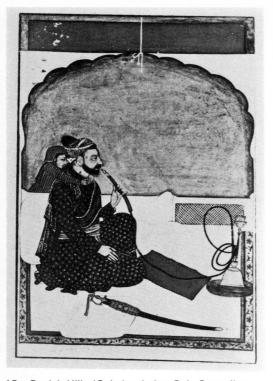

15 Punjab Hills (Guler) painting *Raja Govardhan Singh (1744–1773) of Guler embraced by his Little Daughter* 7 1/2 × 5 in. (19 × 12.5 cm.). Punjab Museum, Chandigarh

Opposite page:

16 P. Bonnard *Nude in a Bathtub* 1935. Oil on canvas 40 1/2 × 25 1/4 in. (103 × 64 cm.). Collection R.T., France © Spadem Paris 1971

but in Persian and Indian painting, its use is quite common (fig. 15).

In his early paintings and drawings, Bonnard used straightforward perspective, but after about 1920 he experimented with all kinds of drawing systems, including vertical oblique, in an endeavour to involve the spectator more intimately in the scene. In this painting, the vertical projection is so oblique that the bath is elongated even beyond its normal length (fig. 16).

In cubist still lifes the use of vertical oblique for jugs and glasses was so common that the form has now become a sort of visual cliché in pictorial illustrations. In Roman, medieval and eastern painting the system was often used for cylindrical objects, even when the rest of the painting was in normal oblique. The reason for this is that cylindrical objects in normal oblique differ so markedly from what we see that the distortion is unacceptable (fig. 19).

One special variety of vertical oblique is known (to architects) as axonometric projection. In this system the object (usually but not necessarily rectilinear) is turned through 45° about a vertical axis before being projected. Empirically, a plan view of the object is drawn at 45° to the horizontal, and the side and front views are added usually with the verticals as true lengths (fig. Isolated examples appear in Byzantine and medieval paintings, but axonometric projection was not used coherently until the architectural drawings of Theo van Doesburg and other members of the De Stijl group popularized the system in the 1920s. The over-riding concern the group, which also included the designer Rietveld and the sculptor Vantongerloo, was with *space* rather than with façades or views; axonometric projection seemed to offer a way of drawing which put the emphasis on this aspect of design, particularly in architecture, rather than

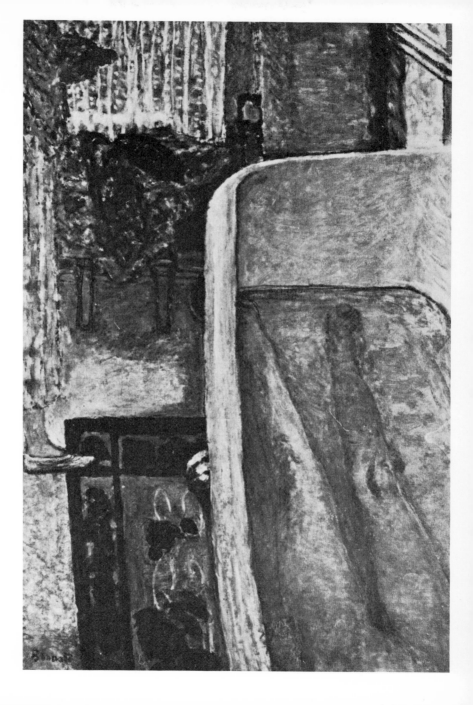

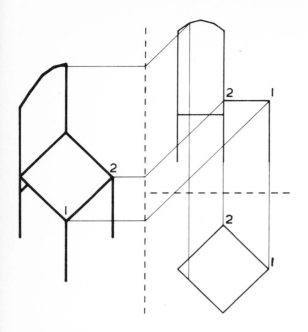

17 Axonometric projection

the conventional orthographic projections or architect's perspectives which tended to inhibit it.

Axonometric projection seems particularly suited to architectural design drawings, as opposed to detail drawings for which orthograp projection is obviously most suitable. Possibly, with the introduction of computer-aided desig its use may become more widespread.

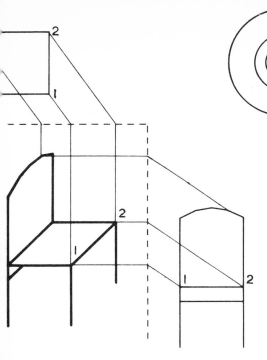

and 19b Oblique projection

Oblique projection

In ordinary oblique projection both the side and top views of the object are tacked on round the edges of the main front view. In order to make these subsidiary views join up, they have to be distorted, so that the edges of the object which run back into the picture or the 'orthogonals' as they are usually called, lie at an angle to the front view. The lengths of these orthogonals may be true lengths, or any proportion of the true length which seems convenient.

Any shadow which the sun throws of an object on to a flat plane will be an oblique projection (fig. 18) and the lengths and angles of the orthogonals will be determined by the degree of obliquity with which the sun's rays strike the plane (figs 19a and 19b). Horizontal and vertical oblique projections are only special

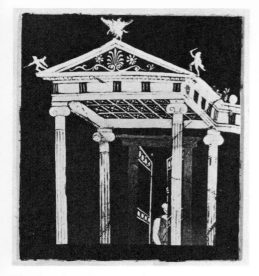

20 Drawing of a temple, from an Apulian vase, fourth century BC

cases of oblique projection occurring when the rays strike the plane at right angles in one direction and orthographic projection is the unique case when this angle is a right angle in both directions. Historically the development of projection systems has been from the most special case to the most general. The degradation of projection systems, when it has occurred, has done so in the same order, but in the opposite direction.

The ease with which a drawing in oblique projection is achieved, compared with the same drawing in perspective, has a powerful appeal. Compared with an orthographic projection, an oblique projection has the advantage of showing three sides of an object without any complicated foreshortening; and compared with horizontal or vertical oblique, it gives a strong impression that the object is solid. For all these reasons, oblique projection has probably been, taking all countries and periods together, perhaps the most commonly used of all drawing systems.

It seems to have appeared first as a development of horizontal oblique, on Greek vase drawings, during the fourth century BC. At any rate there are during that century plenty of examples of drawings of rectilinear objects such as altars, chairs, or buildings (fig. 20) in which the horizontal orthogonals are beginning to move upwards or downwards, so that a top, or underneath view of the object can be added to the existing front and side views. The subsequent development of Greek drawing from this period up to the first century BC is largely a matter of conjecture. Certainly during the Roman period the use of oblique projection for wall paintings was commonplace and it seems natural to suppose that during the period from the fourth to the first century BC, artists gained more confidence in their use of the system.

A good deal has been published[1] recently on the question of whether or not Roman painters achieved the use of artificial perspective. What has less frequently been remarked is that most of the surviving paintings are in fact in oblique projection, or more or less loose variations of it. Certainly in some paintings there seems to be a tendency for the orthogonals to converge and in a few cases there is a definite 'vanishing point' but in at least as many cases the orthogonals are roughly parallel, or even divergent. It may be supposed that in this period, as during the Renaissance, and even up until the nineteenth century, more sophisticated artists tended to use perspective, while the naïve or jobbing painters were content with oblique projection. It does, however, seem unlikely that either oblique projection or perspective was ever thought of by the Roman painters in terms of primary geometry. As with their formal geometry and mathematics, the Greeks and Romans thought in terms of a series of disconnected individual examples, rather than of a general system in which real situations appeared as typical or special cases.

It is however conceivable that after empirical perspective had been more or less mastered, there was a deliberate return during the Third and Fourth style period to a strict version of oblique projection, for the sake of flattening the painting and emphasizing the wall surface. If this were true, a parallel could be drawn between the change from late-Roman to Byzantine painting, and the change from late-nineteenth-century painting to Cubism.

Oblique projection seems to have arrived in China from Rome by way of India round about the first or second century AD. During the journey the perspective element, perhaps never very firmly established, was lost. Throughout its

See especially John White *The Birth and Rebirth of Pictorial Space,* Faber and Faber: London 1967; and Grisela M. A. Richter *Perspective in Greek and Roman Art,* Phaidon: London 1970.

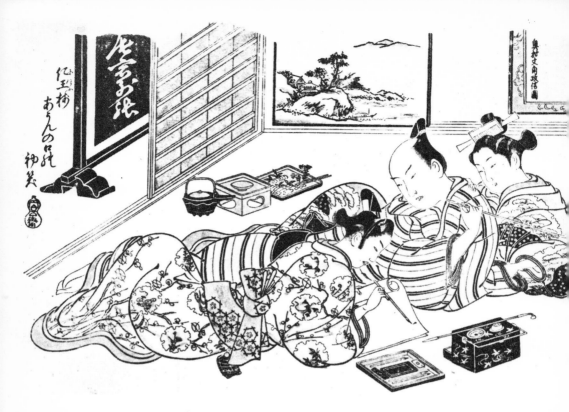

21 Okumura Masanobu (1686–1764) *A Man and a Courtesan watching a Young Man Write*. Woodcut $9^5/_8 \times 14^1/_4$ in. (24.3 × 36.2 cm.). Metropolitan Museum of Art, New York

whole history up until the eighteenth century Chinese painting is remarkable for the consiste way in which oblique projection was used, at any rate so far as rectilinear objects were concerned. The orthogonals are nearly always parallel, and the angle between the orthogonal and the horizontal is usually 45°. Very little use was made of foreshortening, suggesting that th primary geometry was not understood. One difficulty about using strict oblique projection is that since there is no diminution of the size of objects with distance, as there is in artificial perspective, large objects such as trees or mountains will inevitably fill the picture. In Chinese landscapes this difficulty is often overcome by restricting the use of oblique

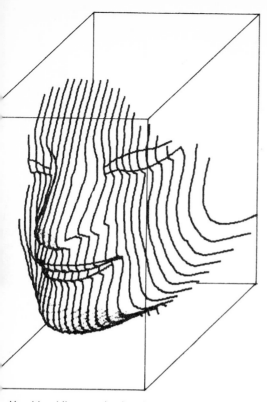

Head in oblique projection, by computer

projection to isolated rectilinear objects (houses) and setting them on the surface a way that the space between them rema... ambiguous. The mountains were then put in, in diminishing scale, as a series of backdrops.

In the Japanese woodcuts of the late eighteenth century rather more sophisticated spatial systems were used. Usually the main objects in the painting appeared in the immediate foreground in isometric or oblique projection, with the landscape in orthographic projection, and a spatial gap between the two. In this respect they resemble early Italian paintings, but in the Japanese woodcuts the mixture of systems often seems more deliberate and more complex. In the engraving *A Man and a Courtesan Watching a Young Man Write* (fig. 21) the artist overcame the difficulty by substituting a painting for the landscape, a technique often used by Vermeer.

Apart from the problem of showing very large objects, drawings in oblique projection may be extended indefinitely in any direction, unlike drawings in perspective which are strictly limited in scope by the size of the visual angle.

Where more complex objects such as figures are concerned, the position is less certain; there is no easy test to determine whether or not a figure is in orthographic projection, oblique projection or perspective. In Chinese painting the figures on the whole seem to be in orthographic projection, and are therefore more or less spatially divorced from their surroundings, even though as individual objects they can appear fairly solid, but in the Japanese woodcuts there does seem to have been some attempt to put the figures as well as the simpler objects into oblique projection. For comparison, fig. 22 shows a drawing by computer of a head in oblique projection.

23 and 24 *The numbering of the People* 1300–20.
Mosaic from St Saviour in Chora (Kariye
Cami) Constantinople

In the West, the use of perspective or near
perspective soon degenerated into a non-spati
use of oblique projection after the fall of the
Roman Empire. For roughly eight-hundred yea
Byzantine painters used oblique projection not
much to describe space as to deny its existenc
Sometimes the orthogonals were reduced to

decorative lines of the surface, or intersected the
front view in such a way as to reduce the drawing
to a flat pattern. Where more than one object
appeared, the orthogonals often pointed in
different directions (figs 23 and 24) and within
single objects the orthogonals were usually
divergent (fig. 25).

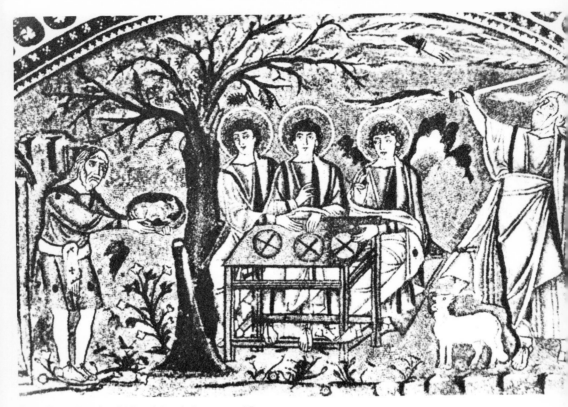

25 *Three Angels* middle of the sixth century AD.
Mosaic from San Vitale, Ravenna

In some cases perhaps these devices were
used deliberately to flatten the picture surface
or to make the intrusion of the images of solid
objects on to curved vaultings covered in mos
less obtrusive. In many cases, particularly in th
more remote parts of the Empire, they probabl
occurred through simple ignorance or misund
standing of the Roman tradition. All the same
apart from serving technical ends, the non-

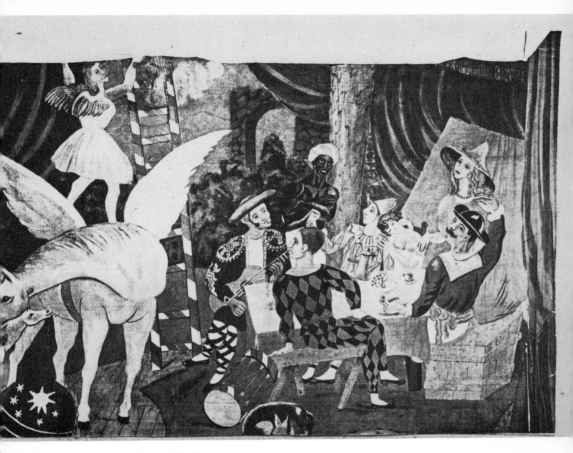

Pablo Picasso 'Backdrop to *Parade*' 1917
© Spadem Paris 1972

spatial use of oblique projection fitted in well
with the mystical beliefs of Christianity, and the
condemnation of naturalism by neo-platonists
like Plotinus. In a similar social and political
climate the use of divergent orthogonals as a
device to flatten the picture surface was taken
up again in our own century by the Cubists,
notably by Gris and Picasso (figs 67 and 26).

33

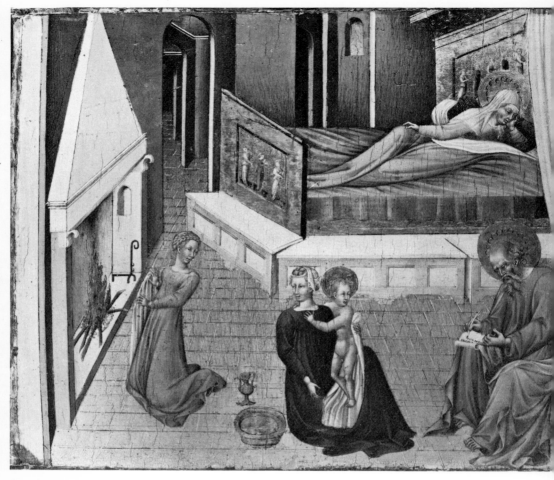

27 Giovanni de Paolo (active 1420 died 1482) *The Birth of St John The Baptist*. Oil on wood (predella panel from an altarpiece) 12 × 14³/₈ in. (30.5 × 36.5 cm.). National Gallery, London

With the beginning of the Renaissance and the rediscovery of real space in painting, there was a tendency for the orthogonals first to become parallel and then to converge. This convergence developed during a remarkably short space of time, and with sophisticated artists like Giotto immediately led on to the formal discovery of artificial perspective. With less sophisticated artists, painting within a workshop tradition, the casual adaptation of oblique projection to a rough and ready empirical perspective persisted for centuries after the formal laws were discovered; probably they made no very clear distinction between the two (fig. 27).

The first artist to use oblique projection as a deliberate *alternative* to perspective, rather than as a crude version of it, seems to have been Leonardo da Vinci. Leonardo was of course perfectly familiar with artificial perspective as described by Alberti, and used it exclusively in his paintings; but many of the drawings in his sketchbook, particularly those of machinery and architecture, are in oblique projection. For the description of these objects, oblique projections, apart from being easier to draw, have a very definite advantage. This is well illustrated by the choice of drawing systems for the illustrations to Diderot's *Encyclopédie,* published in 1758. Where the illustrations show processes taking place (such as the manufacture of pins, or cultivating the land) the scenes are in perspective, but where the objects, or the layout of the workshop, is important, then oblique projection is used (fig. 28). The great advantage for the engineer or craftsman, or the socially conscious amateur for whom the book was intended, was that all lengths along the orthogonals, if not actually true lengths, were at least in constant proportion to each other, so that the illustrations as well as being pictorial could also be used as

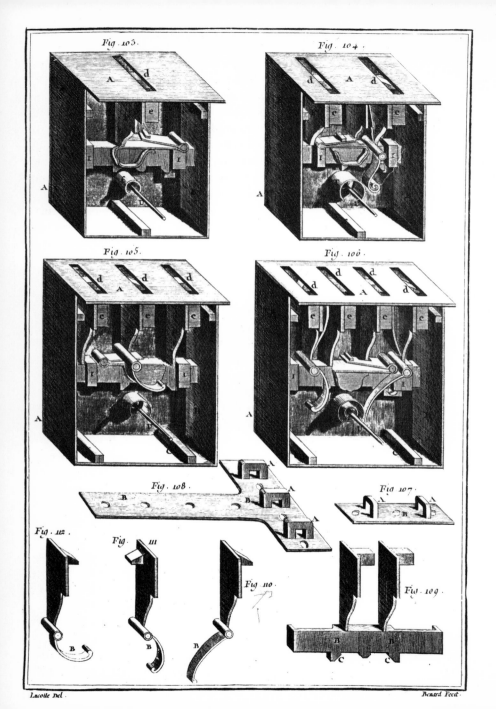

Fig. 103.

Fig. 104.

Fig. 105.

Fig. 106.

Fig. 108.

Fig. 107.

Fig. 112.

Fig. 111.

Fig. 110.

Fig. 109.

Lacotte Del.

Benard Fecit.

working drawings. This functional use of oblique projection lasted until it was replaced by Monge's system of multiple-view orthographic projection: the illustrations to Ree's *Cyclopedia* (fig. 5), published in 1820 are nearly all either in perspective or in orthographic projection. By the beginning of the twentieth century, oblique projection had almost dropped out of use, except for the naïve illustrations in toy catalogues, although it was still taught as a system in engineering drawing until quite recently.

In the arts, no professional painter except for a few eccentrics like Cranach, had used oblique projection since the fifteenth century. The first hint of a change of direction came with the near-orthographic drawing of Ingres and David (Chapter 5).

By the end of the nineteenth century the Impressionists seemed to have brought perceptual painting to a point where no further development was possible, and the post-Impressionists began to turn towards more conceptual systems; and once a change of direction had taken place the new kind of painting developed rapidly. It seems as if simple oblique projection in painting is in the West an unstable condition; for just as with Giotto the transition from the non-space of medieval painting to linear perspective took place within a generation, so a similar but opposite change from the near-perceptual painting of Cézanne to the spatial ambiguities of Cubism was accomplished within a decade.

The subsequent history of painting has been, as in the Byzantine period, largely a matter of tension between conceptual and perceptual systems. The logical extension of nineteenth-century perceptual painting with its emphasis on the involvement of the spectator was out of painting altogether, first into photography and the film, and then into environmental happenings.

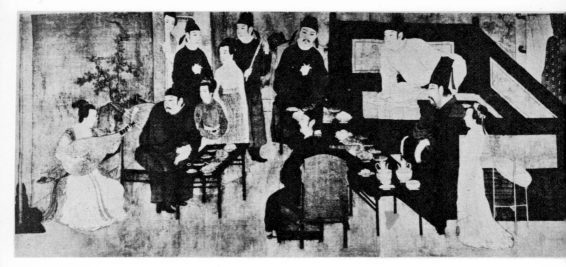

29 Ku Hung-chung *Night Entertainment of Han
Hsi-tsai* (detail) tenth century AD. Colour on silk
11¹/₂ × 133 in. (29 × 338 cm.). Chinese
Government Collection

At the other extreme, the more conceptual
elements of Cubism developed through
Constructivism into minimal and hard edge. Th
middle ground has been occupied by those
painters — De Chirico, Picasso and more recen
Hockney (figs 69, 70 and 71) — who illustrate
this tension without necessarily seeking to
resolve it. In the work of these painters obliqu
projection is used as one element in a comple
mixture of systems.

Orthogonals converging
In the tenth-century Chinese painting *Night
Entertainment of Han Hsi-tsai* (fig. 29), all the
objects are in strict oblique projection but the
directions of the orthogonals are so arranged
they are towards the central axis of the pictur
A comparison of the chairs shows that the
orthogonals represent true lengths. Assuming
that the objects are in reality parallel to each

other, we could make a fairly accurate scale plan of the room. To western eyes this system looks very like linear perspective, but this impression is deceptive. There is no question of a fixed viewpoint, and no change in scale either of figures or objects as they recede in space. To us it seems strange that this kind of drawing did not immediately develop into artificial perspective. Throughout the history of Chinese and Japanese drawing, examples appear which are very close to perspective, but the system was never consistently developed as it was in the West. The need to involve the spectator in the painting is peculiar to the West, and then only in two limited periods: the Roman Empire and later the Renaissance.

It seems likely that painting in both these periods was preceded by an experimental stage, during which objects were drawn individually in oblique projection, but with a general tendency for their orthogonals to converge. The development of painting from the late-medieval period to the Renaissance may be compared to the behaviour of a number of small magnetic compasses placed together on a table. At first their needles (the orthogonals) point only roughly in the same direction, with more or less random variations caused by their mutual attractions (the requirements of the surface composition of the painting). Then a powerful magnet (the spectator) appears. While the magnet is still far away most of the needles will hold their original pattern; as it moves closer the needles click round one by one until they are all pointing towards it.

In the Duccio panel, *The Annunciation* (fig. 30), this development is almost, but not quite, complete. Each part of the architecture of the scene is thought of as an individual piece of oblique projection, but although the orthogonals converge, they do so not towards a vanishing point but towards the angel, the Virgin Mary,

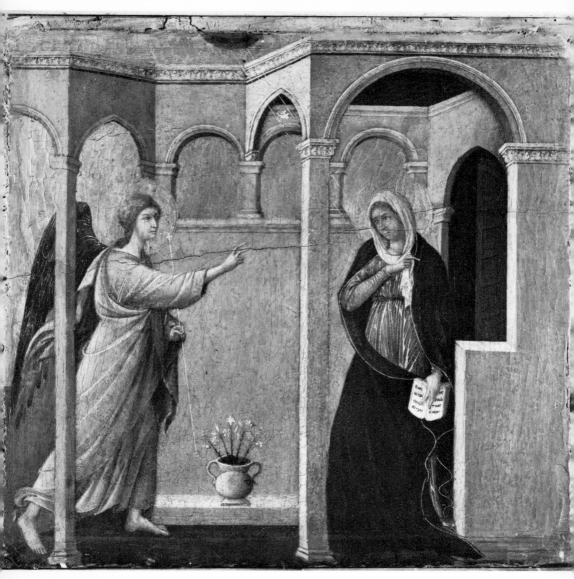

30 Duccio *The Annunciation* 1308–11. Oil on wood
(predella panel from an altarpiece) 17 × 17²/₃ in.
(43 × 44 cm.). National Gallery, London

and the angel's hand — that is, towards important points on the picture surface. This convergence does give a much more perceptual appearance than would have occurred in paintings made a hundred years earlier, but although the space is to some extent measurable, it is measurable only, like the Chinese painting, in terms of oblique projection. Any attempt to analyse the painting in terms of perspective, or even multiple viewpoints, would lead to the conclusion that the space occupied by the angel and the vase is octagonal, which is clearly not the artist's intention. Many of the apparently octagonal buildings and spaces in paintings of this and earlier periods, as well as in Persian and Indian paintings, result from the conjunction of two opposing oblique projections.

Giotto was the first painter after the Roman period to make consistent use of one-point or two-point perspective; his paintings are in fact the first to which the word 'perspective' can properly be applied. There is some controversy as to which of the paintings at Assisi (his first work) can definitely be ascribed to Giotto. The first painting to show an undeniable use of perspective, and which is definitely ascribed to Giotto, is *The Crucifix at San Damiano Speaks to St Francis*. The saint appears in a building which is foreshortened and in two-point perspective. The altar within the building, which carries the crucifix, is however in oblique projection. It would be convenient to be able to trace in Giotto's work a gradual development from oblique projection, first to single-point perspective and then to foreshortened views, but in fact Giotto seems to have been able to cope with quite complicated problems in perspective from the very beginning of his career. Where objects drawn in oblique projection appear in Giotto's paintings (fig. 31), the system is used to indicate

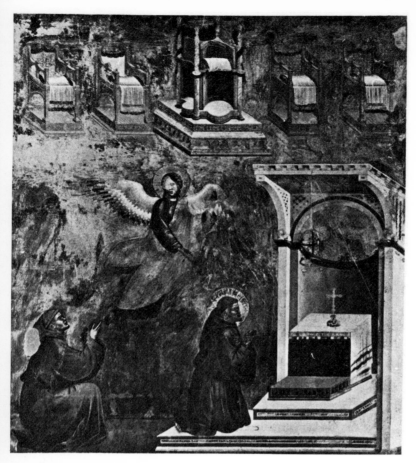

31 Giotto *Vision of the Thrones* 1297—9. Fresco from
 S. Francesco, Assisi

Foreshortening in oblique projection

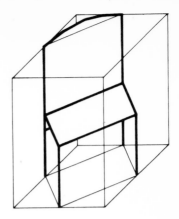

33 Crating

a different kind of space (Chapter 7). Nevertheless it is important to realize that Giotto's space is always defined within or between buildings; there is never a well defined ground base, and to that extent the perspective is always empirical. The discovery of the possibility of describing the position of objects within a given space, rather than implying space by means of objects, was reserved for Brunelleschi and Piero della Francesca during the next century (Chapter 3).

Foreshortening

Any part of an object which does not lie parallel to the picture plane will appear changed in length when projected. This is true of any projection system, but the extent of the change depends on two quite different factors: the angle between the *projection lines* and the picture plane (i.e. the type of drawing system used), and the angle between the *part of the object concerned* and the picture plane. Thus, the side of a chair lying at right angles to the picture plane will disappear altogether in orthographic projection; but can appear as either more than, equal to, or less than its true length in oblique

43

projection or perspective. In addition, if the chair is set obliquely to the picture plane, then all the oblique planes will appear to be diminished. Some very curious effects are produced when both these factors are combined (fig. 32); some of the strangeness of medieval and Persian painting can be accounted for by the attempt to draw objects set obliquely, in oblique projection.

All these changes have been loosely referred to as 'foreshortening' which makes the subject a confusing one for artists, engineers and art historians alike.

While the Greek vase painters were still using orthographic projection, they achieved some very precise drawings of objects set obliquely; for example in *Leavetaking* (fig. 3) the bodies of both the man and the woman, as well as the shield, are turned about a vertical axis and one of the woman's feet is turned about a horizontal axis.

It is rather strange that this interest in foreshortening was confined to the complex problem of the human figure, and was not as a rule extended to simpler objects like chairs and tables. One factor is that with complex objects some part at least *must* be foreshortened, and the Greeks had a good deal of experience of this in connection with relief sculpture. A more important point is that the foreshortening of tables and chairs forces on the spectator an awareness of the three-dimensional space in which they exist, and this the Greeks wanted to avoid. They seem to have used foreshortening, not as the Renaissance painters used it to demonstrate space, but rather to extend the possibilities of surface pattern.

The Roman painters on the other hand deliberately used rectilinear objects, particularly buildings, to 'set the scene' but as these appeared in either oblique projection or empirical

Paolo Uccello *Perspective Study of a Chalice*
c. 1460. Ink on white paper 11 3/8 × 9 5/8 in.
(29.0 × 24.5 cm.). Uffizi Gallery, (Gabinetto dei
Disegni), Florence

pective they showed the space well enough
out the necessity to set them obliquely. At
t, an occasional building or object is turned
ugh 45°; more rarely, an entire scene is
wn from this point of view.

his limited attitude towards foreshortening
nded through Byzantine painting until the
medieval period. By the thirteenth century
increasing awareness of space was showing
f in two ways; through the development of
pective, and through the attempt to deal
more complex problems in foreshortening.
o this point foreshortening had been achieved,

if at all, by 'crating'; that is, by drawing the
object in its foreshortened position within a
larger box or 'crate' which is not foreshortened
(fig. 33).

Uccello was the first artist to deal with fore-
shortening scientifically by the projection of
individual points taken from plan and elevation
(fig. 34). The *Battle of San Romano* is full of
complex objects in perspective, parts of which
are inevitably foreshortened; but the objects *as a
whole* are set at right angles to, or parallel to, the
picture plane. These objects are used to define
the space in the painting; inevitably the 'grain'
of the space runs parallel to the picture plane. The
extent to which this is true of Renaissance
painting generally is quite astonishing; it is rare
to find paintings in which individual objects
(except the human figure) are set obliquely, let
alone the space as a whole. In Japanese prints
however the use of oblique space is not at all
uncommon (fig. 37). No doubt it was partly the
increasing availability of these prints to European
artists, together with the invention of photo-
graphy, which prompted a revival of interest in
foreshortening at the end of the nineteenth
century. Previously, foreshortening had been
thought of in terms of turning an object in
relation to the picture plane; now the ease with
which a camera could be tilted and swung
towards an object suggested to Degas the
possibility of using unusual 'camera angles', an
opportunity which has been widely exploited in
film-making and photography ever since.

The recent advances in computer graphics give
us the same freedom in drawing as did the
camera in optics. A definite meaning is given to
the idea of the direction of space, by the directions
of the axes to which objects are referred; and
the space may be set obliquely by tilting these
axes in relation to the picture plane (figs 6a and 6b).

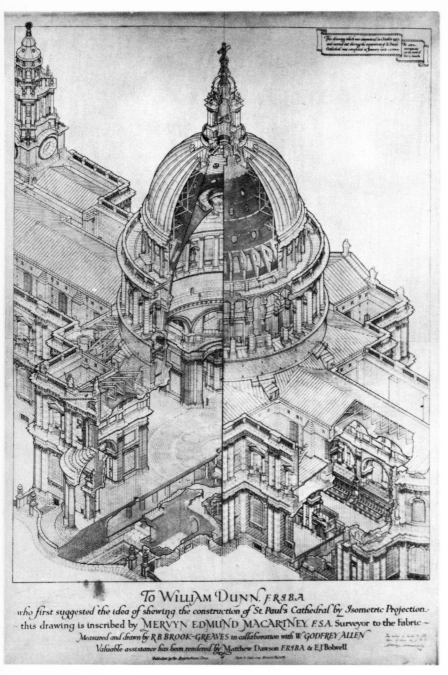

To WILLIAM DUNN. F.R.I.B.A.

who first suggested the idea of shewing the construction of St. Paul's Cathedral by Isometric Projection

this drawing is inscribed by MERVYN EDMUND MACARTNEY. F.S.A. Surveyor to the Fabric

Measured and drawn by R.B.BROOK-GREAVES in collaboration with W. GODFREY ALLEN

Valuable assistance has been rendered by Matthew Dawson F.R.I.B.A. & E.J.Bolwell

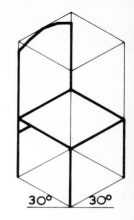

Isometric projection

In an attempt to make the very complex drawings of the industrial revolution more readable, an English contemporary of Monge's, Sir William Farish, introduced a system which he called 'isometric projection' (fig. 35). This combined the use of true dimensions with a more pictorial appearance. At first glance the system seems to be an alternative form of oblique projection, with the top, side and front views drawn as true lengths at equal angles to each other (fig. 36b). Drawings of objects made according to this method had frequently appeared in Roman, Byzantine, Persian and Chinese paintings, and in the eighteenth-century Japanese woodcut the

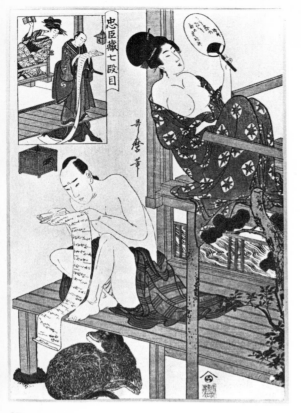

37

empirical use of isometric projection for whole scenes (fig. 37), as well as for individual objects, is at least as common as the use of oblique projection. It is unlikely that artists in any of these periods understood the system in terms of its primary geometry; this is suggested by the way in which rectilinear objects, apparently in isometric projection, are often set within scenes which are otherwise in oblique projection (fig. 21). These were obviously attempts to show these objects in a foreshortened position without the distortions which the use of genuine fore-shortening in oblique projection would have

involved (fig. 32). Vertical oblique projection was used for cylindrical objects for the same reason (figs 14b and 19b).

Isometric projection is in fact a variety of orthographic projection. The object is viewed from the particular direction in which all its side appear equally foreshortened (fig. 36a). One c Leonardo's drawings, which shows a cube turned through these stages into the isometric position, suggests that he understood the primary geometry; otherwise the system seem to have been a genuine innovation.

Isometric projection never achieved the popularity for which its inventor had hoped. It not a suitable system to use for engineering working drawings because, apart from taking long to draw, it compresses too much informa into one view, the reason why oblique project was abandoned. It was most commonly used during the 1930s when the Boeing Aircraft Company, faced with the problem of explainir complicated drawings of aircraft to unskilled assembly workers, started a practice of issuing isometric views alongside the normal working drawings in orthographic projection. Sometim a straightforward isometric view was unsuitab because of difficulties involving false attachm and variations known as 'dimetric' and 'trimeti projections were introduced[2], together with various ingenious and complicated scales for drawing them. This led to the invention of draughting machines (forerunners of the XY plotter) with which these views, as well as perspective drawings, could be drawn with eq facility, so that the simplicity of isometric projection (its main advantage as a pictorial system) became less significant. As a result, th use of isometric projection is now fairly uncommon.

2. Figs 4, 6 and 40 are in trimetric projection.

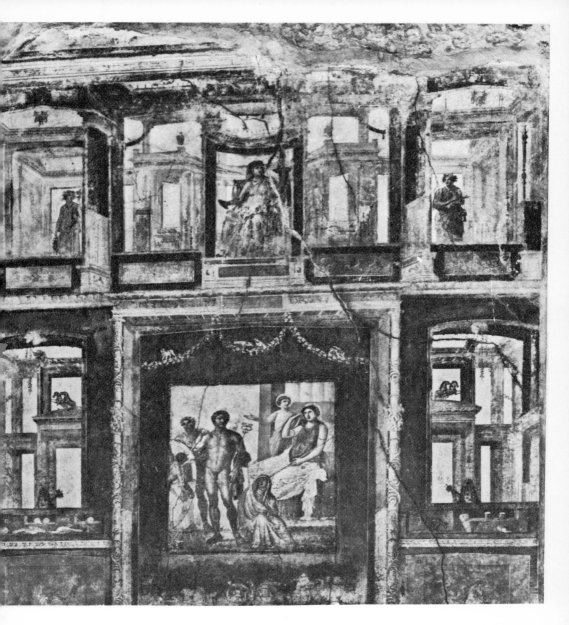

38 Fourth style wall painting (fresco), first century AD. House of the Vettii

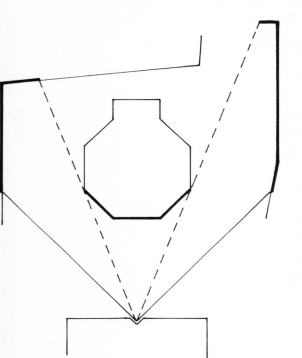

39a

Perspective

The central problem in perceptual drawing is perspective, and the central problem in perspective is the degree of spectator involvement.

Euclid's optics deal in general terms with rays of light in space converging to a point at the spectator's eye: constituting the visual pyramid or cone of vision. In perceiving the geometry of natural vision or natural perspective, Euclid (*c*. 300 BC) cleared a path for draughtsmen and perspectivists of the future; for the empirical methods used in Greek and Roman painting; and for the formal scientific methods developed during the Renaissance and after.

Almost the only surviving examples of Roman painting that exist are to be found in Pompeii and Herculaneum. The first century AD wall painting (fig. 38) in the 'House of the Vettii' is a fairly typical example of this period when a rough and ready empirical system was used. It worth noting, however, that in spite of the fact that the general idea of the convergence of orthogonals to a central point is fairly well understood in this painting, the problem of describing a deep receding ground plan does not occur. The fully articulated ground plan was to play an important part in Renaissance painting when perspective was understood in terms of primary geometry. The understanding that we now enjoy is attributed to the discoveries of two architects, Brunelleschi and Alberti; their system is known as artificial or scientific perspective.[1]

1. Now often called linear perspective as distinct from aerial perspective.

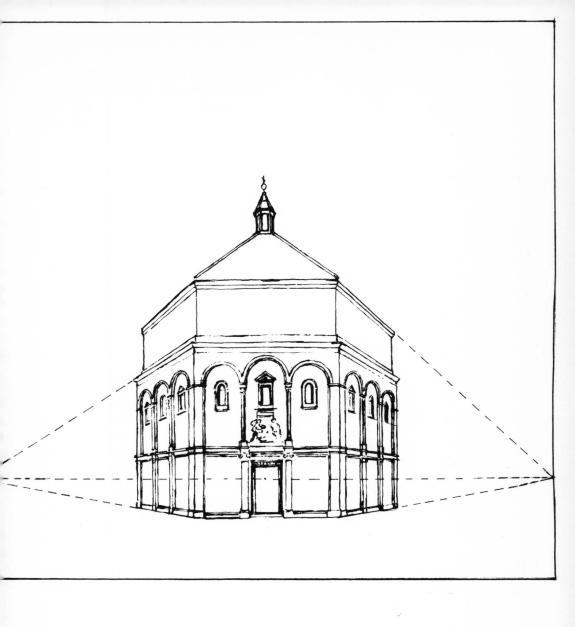

Brunelleschi's biographer, Antonio Manetti,
gives an account of a small picture, about one-
square, that was painted by Brunelleschi in th
first decade of the fifteenth century; this was a
painting of the octagonal Baptistry in Florence
observed from the West door of the Cathedral,
directly opposite the eastern entrance to the
Baptistry. The subject was painted, not directl
but as a mirror image, and the ground used w
a polished silver panel. The plan of the Cathec
in relation to the Baptistry (fig. 39a) and
Vasari's account of the picture which names t
additional buildings that were shown, suggest
that the visual angle was 90°. If this is correct,
the basic geometry of the picture would have
looked like the drawing (fig. 39b). Moreover,
this is a convenient and plausible arrangement
because the vanishing points for the planes of
the Baptistry at 45° to the picture plane conve
to two points on the horizon in coincidence w
the edges of the picture, and equidistant from
the central vanishing point. These are very
practical considerations when an artist is work
on the spot, because all the construction point
occur on the picture surface. The buildings we
painted with the care of a miniaturist, but the
was left unpainted, leaving the burnished silve
ground.

At the central vanishing point in the picture
(that is the point at which orthogonals represe
ing lines at right angles to the picture plane
converge), Brunelleschi pierced a hole. He the
directed that the spectator, holding the picture
one hand, should look through the aperture at
the back of the silver panel to a mirror held in
the other hand. The spectator could then see a
correct rather than a reversed image of the
Baptistry and surrounding buildings, with an
apparently real sky above, this being a reflecti
of the sky on the silver and unpainted part of

picture. As the painting is now lost, so that
ubstantial clues remain, there is some
rgence of opinion among scholars about
elleschi's working method at the time when
irst drawing for the picture was made. Some
ider that he measured the Baptistry and
uced the drawing by means of secondary
netry, a projected plan system based on the
ary geometry of the optics involved. Others
tain that he painted directly on top of a
or image of the Baptistry reflected in the
nal silver panel. What is certain is that
re this time there was no known method of
ng a perspective drawing from a plan and
ation. The important point is that Brunelleschi
onstrated at the same time a number of
ciples upon which the foundations of
cial perspective are laid:
e spectator should use one fixed point for
s observation.

central perspective parallel lines converge
a single point, the central vanishing point.
ie picture plane intercepts the visual cone.
ie two planes running at 45° to the picture
ane converge to points on the horizon
uidistant from the central vanishing point,
d the distances from these points to the
ntral vanishing point are the same as the
stance of the spectator from the picture.
ould be false to suggest that Brunelleschi
e all these discoveries. For example,
emy (second century AD) in addition to
esting a formal projection system in relation
ap-making, had shown how points
sponding to the intrinsic geometry of objects
d be marked on a mirror. Also, the fact that
lel lines are seen to converge was generally
pted by artists in the year 1400.
unelleschi's demonstration was really an
gamation of known facts in a most ingenious

form. In his peep-show, he demonstrated for the
first time a complete understanding of the
primary geometry, i.e. the relationship between
spectator, picture plane and object and the
resulting visual array formed by projection lines
intersecting the picture plane. It is perhaps worth
noting that every time we take a snapshot with
a camera, we are in fact re-enacting
Brunelleschi's experiment; the result depending
on the relationship between the spectator's eye,
the film representing the picture plane and the
object being photographed.

Alberti's contribution to the system of scientific
perspective is contained in the *Della Pittura*,
which he wrote in 1436. The *construzioni legittima*
or 'best method' (Alberti said 'I found this the
best method'), described scientifically the
construction of a chequered ground plan in
perspective. Hitherto draughtsmen had construct-
ed a projected ground plan by non-scientific
means: studio practice consisting of methods
like diminishing each receding square by one-
third.

'Best method'

The bones of Alberti's 'best method' are contained
in the diagrams, figs 40a and 40b. In fig. 40a,
the picture plane is placed vertically, with the
base line joined to the near side of a horizontal
chequered floor. Another plane containing **V**
(vanishing point) and **SP** (spectator point) is set
at right angles to the picture plane though **00**.
The array of projection lines from the chequered
floor passes through the picture plane, forms on
it an image of the floor in perspective, and ends
at the spectator point. The orthogonals of this
image must necessarily meet at the vanishing
point.

In fig. 40b the plane containing the spectator
point, **SP**, has been folded back about the axis **00**

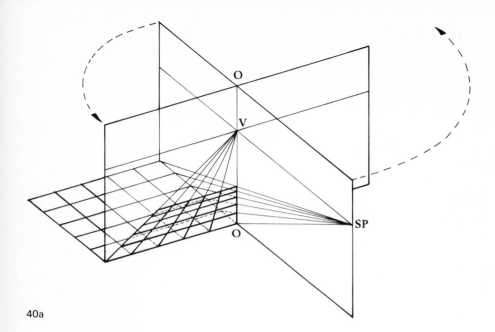

40a

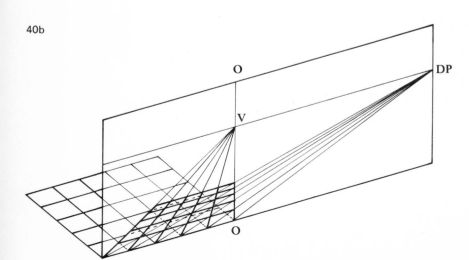

40b

on to the picture plane: this point is now called **DP** (distance point). The lines representing the visual rays must inevitably fall across the diagonals of the squares, showing that the distance from the vanishing point to the spectator point is the same as the distance from the vanishing point to the distance point. Thus the triangle **SP – V – DP** (figs 40a and 40b) is a right-angled isosceles triangle, so that two of the angles are 45°. This brings us back to Brunelleschi's painting of the Baptistry; the two receding planes of the octagonal Baptistry at 45° to the picture plane (fig. 39b) are converging to points on the horizon. These points are therefore the distance points, and accordingly indicate the distance of the spectator from the central vanishing point. It can now be seen that Brunelleschi invented the distance point method and that Alberti supplied the scientific proof. Alberti must in addition be given credit for comparing the picture plane with a window frame.

Leonardo's contribution to the techniques of artificial perspective concerns using perspective backwards, that is elucidating information about the position of objects in space by using linear measurements taken from paintings and drawings. He wrote: 'If you draw the plan of a square (in perspective) and tell me the length of the near side, and if you mark within it a point at random, I shall be able to tell you how far is your sight from that square and what is the position of the selected point.' Leonardo then goes on to explain the procedure; an adaptation of the method is as follows. (In Leonardo's description of the procedure, the central vanishing point **V** and the side view of the picture plane **VG** are not in coincidence. The result however is precisely the same.)

Take a square **ABCD** (in perspective) (fig. 41). Produce **AD** and **BC** to intersect at **V**.

The point **V** is the central vanishing point (on the horizon or eye level). Produce the diagonal **AC** to meet the eye level; this gives the distance point **DP**. Mark off a number of equal divisions along **AG** passing through **B**. Join these points to **DP** and **V**. The intersections on **VG** will give the horizontal co-ordinates and the intersections along **AB** will give the orthogonal co-ordinates. 'Scale your drawing' Leonardo says, 'and you see the position of your point marked at random in the square.'

Mechanical aids to drawing

In Dürer's treatise on measurement, published in 1525, there are four illustrations of drawing machines. These are directly related to Brunelleschi's practical demonstration and Alberti's definition of the picture plane as a window: a plane or window in space where the spectator decides that he will intercept the visual rays that converge on to his retina. Dürer's machines also demonstrate the necessity for maintaining fixed spectator point (sometimes called the station point or observation point).

41 'Leonardo's method'

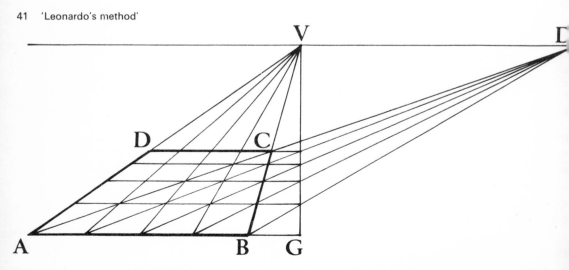

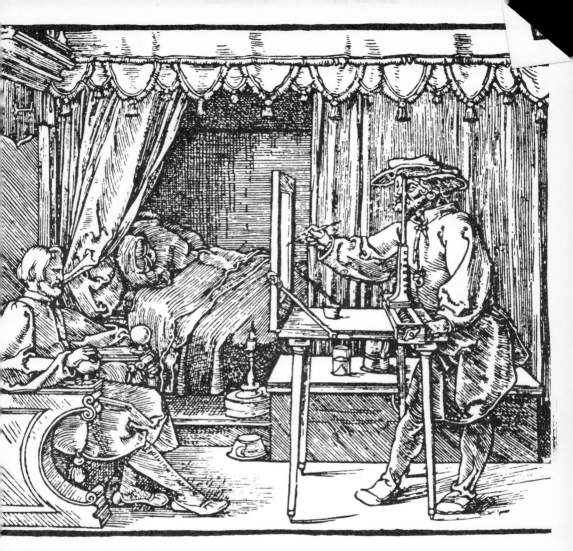

...thod of drawing a portrait

...g. 42 the artist is seen drawing a seated man
...a pane of glass, keeping his eye in one place
...ooking through a sight vane. 'Such is good
...all those wishing to make a portrait but
... cannot trust their skill', recommends Dürer.
... artist simply traces the contours that appear
...he glass, with a paint brush. The drawing

that results is transferred to a panel ready for
painting.

There is a drawing of a similar machine in one
of Leonardo's notebooks; probably Dürer learnt
of the device when he met Leonardo in Venice.

By using a window with a view, closing one
eye and keeping the head still, it is possible for

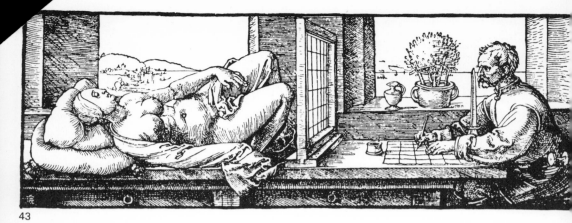

43

anybody to demonstrate the principle of the machine. A chinagraph pencil or white paint may be used for tracing the outlines.

A man drawing a recumbent woman
Again the spectator keeps his eye in one place by using the sight vane. The frame (picture plane) is here covered with a network of lines; squared up like a map. The spectator's drawing paper is also squared up, not necessarily to the same scale. As the contours are observed in relation to squares within the frame, these

contours can then be drawn on to the corresponding squares on the paper. By using this method, Dürer shows the man overcoming the difficulties involved in a close-up fore-shortened view, also that this is a good method for reducing or enlarging a drawing proportionally.

A man drawing a vase
In 'method of drawing a portrait', the spectator is restricted to the size that he can

44

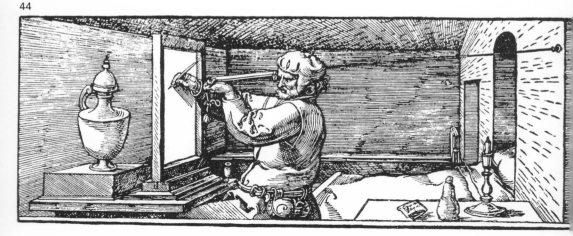

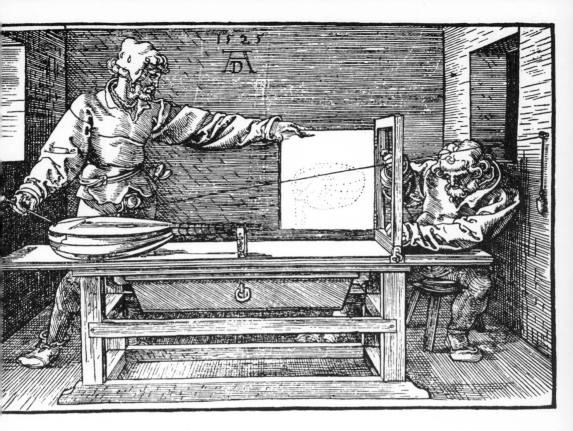

ke his drawing by the length of his arm plus
brush. When light rays converge to the
ctator's eye, the size of the image formed by
intersection of these rays on the glass or
ure plane is the size that can be seen, so
drawing is sight size. Sight size can be
nitely variable and depends on the distance
ween the spectator, the picture plane and
object. 'A man drawing a vase' method
ends the possibilities of size and spectator
ance from the picture plane, by substituting
all and socket joint attached to the wall for
visual cone. The use of a rigid bar with a

plain sight at the operator's end and the ball and
socket at the other end simulates a single ray of
light. The operator aims at the vase, tracing the
contours on to the glass, moving his head with
the contour because the bar is rigid. The machine
is nicer in theory than in practice, although
perhaps a skilled operator could produce good
results.

A man drawing a lute
This method also provides for those who require
long-distance projection; it also removes the
tiresome business of looking through a sighting

device. It does however require two operators, one for calculating, and one for drawing. A simple pulley is attached to the wall, a piece of string passes through the pulley with a weight at one end and a pointer at the other end. The pulley is substituting for the spectator's eye, the apex of the cone of vision. The string from the pulley to the pointer represents a single ray of light and passes through the picture plane. As man with the pointer fixes different reference points on the lute, his assistant measures off the vertical and horizontal co-ordinates and pl each new point on the drawing. When there a enough points, he joins the relevant ones, and completes the drawing.

Dürer's machine has its modern counterpart in digitalizers like the DMAC. In the two-dimensional versions, a sighting device or 'hedge-hog' is run around lines or contours by hand. The co-ordinates of a very large number of points along the lines are automatically recorded on magnetic tape. After filtering, these co-ordinates may be transformed by computer, according to any projection system, and the result displayed on a cathode ray tube or line plotter. If a DMAC is not available, co-ordinate may be obtained by ordinary measurement, or b using a conventional cartographer's digitalizer.

The camera obscura

The camera obscura was first used for observin eclipses; it was not until the mid-sixteenth century that Giovanni Battista della Porta popularized its use as an aid for artists. Subsequently over the next three centuries mar variations of the camera obscura were designec and made; a typical eighteenth-century model is illustrated (fig. 46)[2]. Basically this model consists of a mirror at the top, a double convex lens and a small dark enclosure. The observer

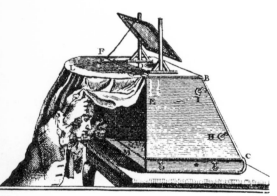

46

2. For general information concerning drawing instruments see:
Joseph Meder *Die Handzeichnung, ihre Technik und Entwicklung,* second edition, Vienna 1923.

places his head and hands inside the enclosure making sure that no unwanted light enters and stands with his back to the subject. An image of the subject being observed is deflected by the mirror through the lens and on to the paper at the bottom of the enclosure, where the observer may trace round the contours of the projected picture. Sir Joshua Reynolds used a collapsible version of the model illustrated which folded into a box resembling a leatherbound library folio, now in possession of the Science Museum, London.

A variation of the camera obscura was adapted by Fox Talbot for photography; the first photographic camera was a single-lens reflex.

Vermeer

In 1629, three years before Vermeer was born, an extensive work on perspective was published in Amsterdam by Samuel Marolois in which the principles that were laid down by Alberti were restated and elaborated. During Vermeer's working life in Holland, Descartes was inventing co-ordinate geometry and Spinoza was making the best lenses in Europe for telescopes and microscopes; from this time optical instruments were to become increasingly efficient.

This age of reason when art and science were happily married was characterized by measurement; measurement in terms of observation and measurement in terms of mathematics.

Vermeer, of all seventeenth-century artists, strove to achieve complete identity with his subjects. It is therefore apposite to scrutinize and measure one of his pictures, Lady and Gentleman at the Virginals (c. 1662, 29 × 25 1/2 in. [73.7 × 64 cm.] fig. 47). For linear measurement of a painting or photograph it is necessary to work perspective backwards, by Leonardo's method (fig. 41). (All measurements are quoted

Page 62:
Johannes Vermeer The Music Lesson (A Lady at the Virginals with a Gentleman) c. 1665–70. Oil on canvas 29 × 25 1/4 in. (73.7 × 64 cm.). Royal Collection, The Queen's Gallery

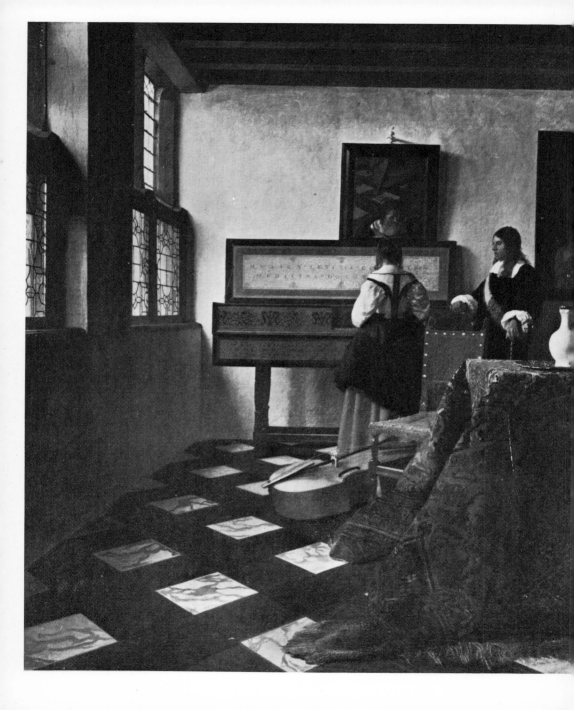

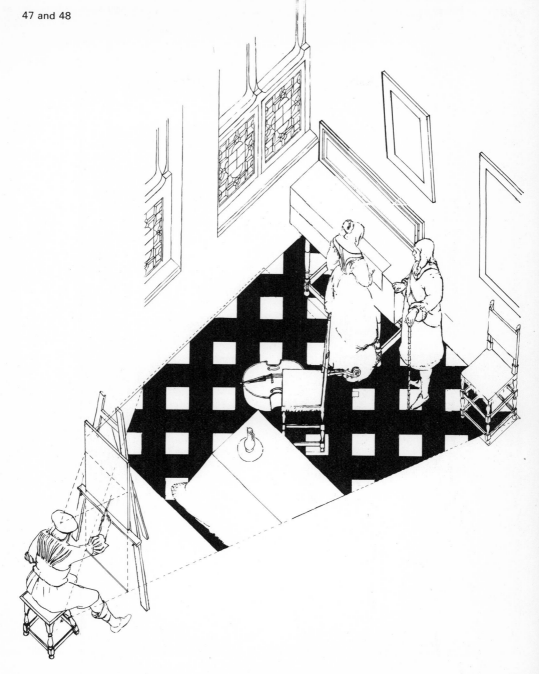

as they would be from the painting itself.)

1. Find the vanishing point at the intersection the orthogonals.

2. Draw a horizontal line (eye level) through vanishing point.

3. Extend the edges of the diagonally patterned squares on the floor to intersect the eye level

4. Measure the distance from these intersection to the distance point – 27.6 in. (70 cm.) on side and 29.6 in. (75.2 cm.) the other side

5. These distances should be equal; if they are not, take the mean, 28.6 in. (72.6 cm.). The is the distance of the spectator (Vermeer) from the canvas. The discrepancies between the points where the squares converge on eye level may be attributed to lens distortion or inaccurate drawing either by Vermeer or ourselves.

6. Measure the height of the lady in the painting 10.2 in. (25.9 cm.).

7. Assume that her real height is 5 ft, i.e. 60 in (152.4 cm.). In this case a guess based on probability that Dutch gentlewomen in the seventeenth century were not generally very tall.

8. Let her real distance from the spectator be inches.

9. Then by similar triangles:

$$\frac{D}{60} = \frac{28.6}{10.2} \qquad D = 168 \text{ in.}$$

$$\left[\frac{D}{152.4} = \frac{72.6}{25.9} \qquad D = 426.7 \text{ cm.} \right]$$

10.2"

28.6" D inches

10. Measure the length of the diagonal of a square on the same level as the lady, 2.40 in. (6.1 cm.).

11. The real length of this diagonal must be:

$$2.40 \times \frac{60}{10.2} = 14.1 \text{ in.}$$

$$\left[6.1 \times \frac{152.4}{25.9} = 35.9 \text{ cm.} \right]$$

12. By counting the squares on the floor in the painting, a ground plan of the room may be drawn up.

13. Draw in the picture plane and the spectator point on the plan.

14. Draw in the visual angle. This should meet the corner between the floor and the left-hand wall at the point shown in the painting, providing an independent check of the system and the assumption made about the lady's height.

15. In this case the agreement is good; if it is only fair then the process from (6) must be repeated, making a new assumption: this process must be continued until the necessary accuracy is obtained.

16. To find the dimension of any other object in the painting, compare its measurements with those of a square at the same distance in space from the spectator. If the picture length of the diagonal of the square is **L**, and the picture measurement of the object is **m**, and the true measurement of the object is **M**, then:

$$\frac{\mathbf{M}}{\mathbf{m}} = \frac{14.1 \text{ in. } [35.9 \text{ cm.}]}{\mathbf{L}}$$

$$\mathbf{M} = 14.1 \text{ in. } [35.9 \text{ cm.}] \times \frac{\mathbf{m}}{\mathbf{L}}$$

17. By this means the size of any object in the painting may be found and the plan and elevation views drawn, providing all the

necessary information for an axonometric drawing (fig. 48) or even a *tableau vivant*. As we shall see (fig. 50), when the visual angle exceed about 25° distortions occur towards the edges of pictures. In *The Music Lesson,* where the visual angle is 45°, the squares at the bottom of the picture begin to distort. Vermeer disguised this on the right-hand side of the picture by covering the squares with a carpet, and on the left-hand side by cutting the squares with the picture plane. The disadvantages of possible distortions were probably carefully weighed against the feeling of intimacy that he achieved by drawing the spectator into the room, to sit by the table and observe the music lesson. The plan also reveals the care with which Vermeer placed the objects in the room. Note how the harmony of movement in space is obtained by placing the figures and the furniture either parallel to the picture plane or following the diagonal pattern of the squares on the floor.

The calculations may be checked optically by using a similar tracing apparatus to fig. 42 (Dürer) with a fixed eye piece at 28.6 in. (72.6 cm.) from the picture plane, and employing the services of a 60 in. (152.4 cm.) lady standing 168 in. (426.7 cm.) from the eye piece; it will be seen that Vermeer painted *The Music Lesson* sight size; and the image of the lady on the screen will be 10.2 in. (25.9 cm.) which is the same as in the real painting.

Vermeer's methods of preparing for a painting are not precisely known. It is known however that he used a type of camera obscura with a vertical screen. To get a reasonably clear image indoors it is necessary even now using large modern lenses to choose a subject with strong tonal contrasts. *The Music Lesson* is a very black and white picture which suggests that Vermeer required strong contrasts. The vertical-screen camera obscura which gives a direct image has the advantage over the flat-bed type in that to turn light rays through 90° a mirror or a prism must be used; even a good quality thin mirror can cut down the light value by as much as 20 per cent.

In discussing a seventeenth-century painting it would be a serious omission not to mention light, and hence aerial perspective or atmospheric perspective. This does not mean that the effect of the atmosphere on light had never before been correctly perceived. Ptolemy, discussing architectural painting of buildings seen at a distance, says poetically that painters employ 'veiling air'. It was Leonardo who gave the name aerial perspective to the effects of graduated tone and colour in space. But in the seventeenth century there was a particular obsession with light; from Rembrandt's sensitive use of light to reveal an expression on a face to Vermeer's meticulous observation and measurement of the play of light on form, and to Charles II Observatory at Greenwich for seeing the light from stars never before seen.

Chapter 4

Multiple cones of vision

Binocular vision: distortion
It is important to understand that artificial
perspective is only valid as a system when
uniocular vision is used, because the array of
visual angles using binocular vision is different
for each eye. For example, if we line up a distant
object with a vertical glazing bar in a window
that is three or four feet away, by closing and
opening each eye in turn the glazing bar will
appear to be either to the left or right of the
distant object. By doing this we are demonstrat-
ing the effect of binocular vision. Because we
nearly always look at pictures with both eyes and
walk about in front of them we are almost
immediately aware of the picture surface and its
flatness. The exceptions are when we are far
enough away for the effects of binocular
vision and motion parallax to be cancelled out,
as in some mural paintings when the spectator
point is carefully defined and is at a great
distance[1]; or in *trompe l'oeil* painting where the
space is so shallow that again the effects of
binocular vision and motion parallax are
minimized. Any photograph or naturalistic
painting will appear to have more illusion of
space when it is viewed with one eye placed
accurately at the centre of projection.

Stereoscopic pictures or drawings require two
different perspective projections, each presented
separately with the correct centre of vision for
each eye, and viewed simultaneously.

1. *Optics, Painting and Photography,* M. H. Pirenne
 1971. Chapter 7. 'The simple theory of linear
 perspective.'

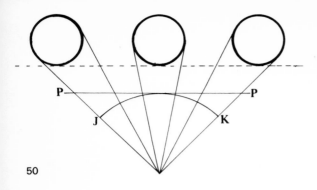

50

The diagram (fig. 50) which has been adap[ted]
from one of Leonardo's notebooks shows ho[w a]
line of circles appears on a picture plane whe[n]
viewed from a single spectator point using th[e]
artificial perspective system. It will be seen th[at]
the intercepts, representing the circles on the
picture plane **PP** get wider as they recede fro[m]
the spectator point. This seems to conflict wit[h]
our experience, as we know that like objects
appear to get smaller as they recede from the
spectator. When a curved picture plane is use[d]
JK, to intercept the visual rays, the images
appear to have a natural relation to each othe[r]
diminishing as the visual angle[2] becomes wid[er]

Leonardo advised that the spectator should
place himself at a distance equal to three time[s]
the length of the longest dimension of the ob[ject]
being drawn, in order to avoid unnatural
distortions. This provides a visual angle not
exceeding 25°. In photography the nearest
equivalent to an angle of view of 25° is obtai[ned]
using a telephoto lens of about 100 mm. on a[]
35 mm. camera.

When a drawing or painting is described as
having a wide visual angle using a strict syste[m]
of artificial perspective, this implies that distor[-]
tions will occur towards the edges of the pain[t]
unless the spectator's eye is in exactly the righ[t]
place, i.e. the spectator point.

In normal roving vision we are not aware o[f]
distortions to objects because our centres of
vision are constantly changing to accommoda[te]
and rationalize new images both in a vertical a[nd]
horizontal plane. In this connection, it is wort[h]
looking at a very curious and eccentric picture
by the Dutch painter Saenredam. The right-ha[nd]
side of a photograph taken with a camera usin[g]
an angle of view of 130° (fig. 51) would prod[uce]
deformation of objects similar to those in the
painting by Saenredam; the interior of *The*

2. Because of the analogies that are drawn between the
human eye and the camera it is likely that confusion
may arise between the size of the cone of vision of
the human eye and the angle of view in a camera.
To clarify this distinction, in future 'cone of vision'
will be related to human or natural optics and
'angle of view' to photographic optics. Also, the
angle that is subtended between the spectator's eye
and the width of the picture plane will be described
as the visual angle. (It is generally agreed by painters
and photographers that 25° constitutes a normal
cone of vision.)

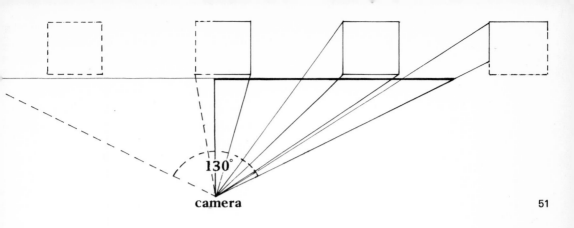

Grote kerk at Haarlem (fig. 52). When this painting is looked at as one would expect to look at a painting measuring 23 $\frac{7}{16}$ × 32 $\frac{1}{8}$ in. (59.5 × 81.7 cm.), that is between eight and nine feet (3 m.) away, it is obvious that the drawing is distorted. On the central column in the picture, the edges of the roll at the point where the base and the shaft of the column meet, are not parallel to the picture plane as one would expect them to be. If also the column on the right-hand side of the picture is completed, it is seen to be very distended (fig. 53). However, the most dominant note in the picture is the black escutcheon on the centre column. When the painting is viewed from a normal central position, this dark note appears to be, and is in fact, true in shape and parallel to the picture plane. A casual observer may therefore be deceived into believing that the whole picture is quite normal and without peculiarities.

The central vanishing point, the point at which the orthogonals converge, is near the centre of the base of the column on the left-hand side of

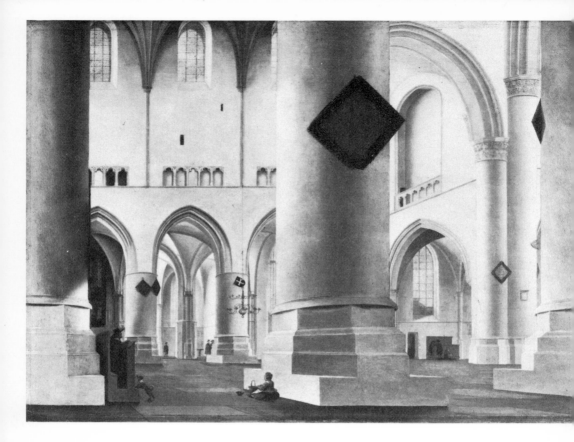

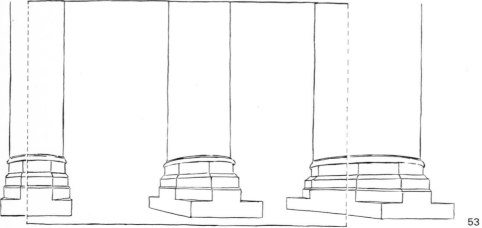

the picture. The Leonardo method (fig. 41) reveals that the spectator point is 17 1/2 in. (44.5 cm.) from picture plane. If the spectator's eye is placed exactly at this point and then rotated through 45° to the right, the column in the centre of the picture will then appear to be normal and circular without a trace of distortion. The effect is achieved because, in moving his eye to the right, the spectator therefore moves the centre of his cone of vision to the right; at the same time the picture plane appears to converge also to the right in perspective. The left-hand side of the roll at the bottom of the centre shaft now appears to be parallel to the right-hand side; the shaft also assumes its true form. The centre panel (in shadow) of the base of the column appears to be parallel to the spectator's eye, since it is at right angles to the cone of vision. Planes and lines that are parallel to the picture plane, including the black escutcheon, now converge to a point outside the picture plane, the system appearing to have changed from one-point to two-point perspective.

Saenredam was the first realist of Dutch architectural painting, and he was the first to master the problem of the close view point[3], thus paving the way for Vermeer (who used a visual angle of 45° in *The Music Lesson*). He was a trained architectural draughtsman, accustomed to making drawings from measurements, which is the way he prepared the cartoons for his paintings.

Fouquet, in *The Annunciation of the Death of the Virgin* (fig. 54), presents the spectator with a fairly wide visual angle. This painting does not, however, make the same demands on the spectator as Saenredam's church interior. In *The Annunciation* it is not necessary for the spectator's eye to be in exactly the right place. The picture

Opposite page:
Pieter Saenredam (1595–1665) *The Grote kerk at Haarlem*. Oil on panel 23 7/16 × 32 1/8 in. (59.5 × 81.7 cm.). National Gallery, London

3. B. A. R. Carter 'The use of perspective in Saenredam', *Burlington Magazine*, 109, pp. 594–5, 1967.

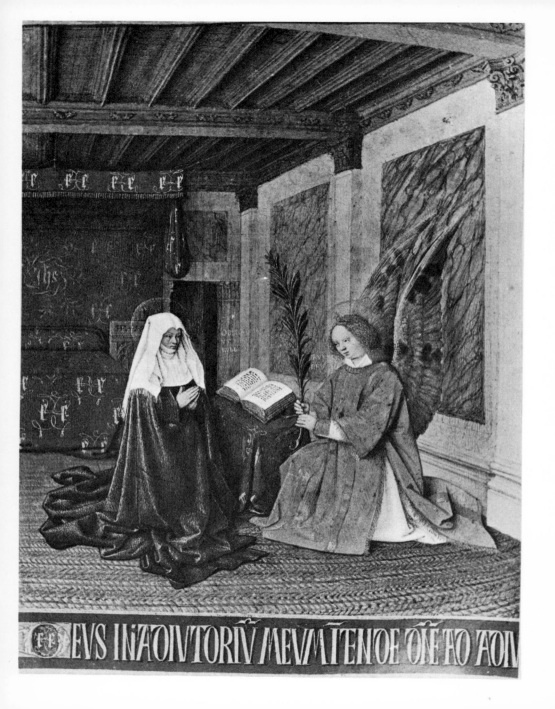

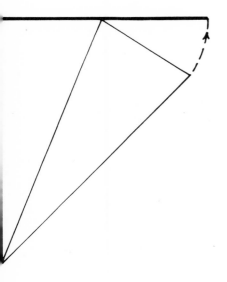

The intersection of the orthogonals is on the extreme left-hand side of the picture, on a line just above the Virgin's head; this is the main central vanishing point, and this part of the painting is in single-point perspective. On the right-hand side of the painting, however, the lines parallel to the picture plane both on the floor and the ceiling begin to converge to a point outside the picture plane, the secondary picture plane thus being in two-point perspective.

It is fairly clear how Fouquet composed *The Annunciation* (although the result was probably achieved in a rather more empirical and intuitive way than we have suggested) but it is not easy to understand why he used the kind of perspective devices that have been discussed. There appears to be little substance in the proposition that the distortions were used in order to preserve the shape of objects. There would have been more distortion of the pattern in the rush matting had the lines not curved, and the spaces between the columns on the right-hand side of the picture would have been more exaggerated, but these are, however, not important objects in themselves and their distortion would not materially have affected the composition. It is possible that the reason for having two cones of vision in the picture, regardless of the resulting deformations, is that Fouquet wanted to emphasize the idea of the angel and the Virgin occupying different kinds of space: the Virgin occupying the spectator's earthly flat and angular space and the angel outside the spectator's main cone of vision occupying a heavenly and curved space. The book (presumably *The Bible*) between the two figures provides a link between the flat space and the curved space, in the same way that the angel provides a link between the heavenly, perfect space and the earthly, imperfect space in Giotto's *Vision of the Thrones* (fig. 31).

be viewed effectively from any position, but penalty is that the lines parallel to the ure plane are not straight, nor do they remain llel. Unlike Saenredam, Fouquet made the essary adjustments for the spectator, in effect g a secondary cone of vision and a secondary ure plane at right angles to it (fig. 55). his secondary picture plane was then folded k and smoothed on to the main picture plane.

56 Vincent Van Gogh *Vincent's Room* 1888. Oil on
canvas 28 ¹/₂ × 36 in. (72.4 × 91.4 cm.). The
Art Institute of Chicago

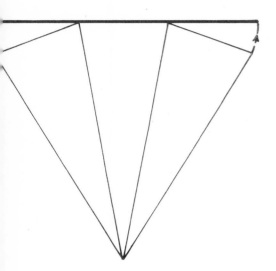

Van Gogh

Coolness and detachment are not words that can be used to describe Van Gogh's work or his life style. When he painted his bedroom, *Vincent's Room* 1889 (fig. 56), he was clearly anxious that the spectator should be drawn in to share an experience. One of the ways he did this was to use a wide visual angle made up of multiple cones of vision (fig. 57); in doing so, he had to sacrifice the known shape of the room. The floor is curved, converging to vanishing points to the left and right of the picture; this in turn caused the nearest chair and the bed to converge in accord. Had Van Gogh used a single wide visual angle, objects at the edges of the picture would have been grossly distorted; as it is, by using a similar method to Fouquet, each separate object appears to have its own centre of vision, its own orthogonals and vanishing point. To Van Gogh the chairs, the bed and the pictures were like icons, and their shape and identity had to be preserved. At the time when *Vincent's Room* was painted, he was very interested in Japanese prints, where here also the spectator's eye is not fixed and great stress is placed on preserving the identity of objects. In Japanese prints however the result is achieved by the use of oblique projection. It is fascinating that Van Gogh should have used a totally different method to achieve a similar end.

To discuss a painting like this without a word about the use of colour would be a grave omission. In a letter to Gauguin he says, 'The colours are flat but laid on in rough impasto, the walls pale lilac, the floor is broken faded reds, the chairs and the bedstead chrome yellow, with the pillows and sheet a very pale lemon green; the coverlet blood red, while the dressing table is orange, the washbasin blue and the window

green.' The edges of the coloured surfaces are defined by a dark line; clearly there is no attempt to use colour or drawing in an illusion way and there is no directional lighting; instea the objects give off their own light.

Referring again to Leonardo's diagram (fig. it seems that if multiple cones of vision are required, it is logical to use a curved picture plane. Monet's passion for recording visual sensations led him naturally to explore this possibility. A series of his water-lily pictures w painted specially for two oval rooms at the Orangerie in Paris, the spectator being as it we surrounded by a lily pond.

In photography the use of a panoramic cam allows a very wide visual angle to be used wit out distortion to individual small objects. This method is largely used for group photographs where a large number of people wish to be see sitting together. A camera is set in the middle c a carefully marked semicircle, the camera move through 180° keeping a constant distance between the camera and the semicircle of peop By folding back and flattening the semicircular picture plane, the people then appear to be sitt in a straight line parallel to the picture plane. A in the Fouquet and Van Gogh paintings, the penalty for using this device is that the known structure of the ground plan is distorted.

Since the beginning of this century there has been a desire by many artists to increase the spectator's degree of involvement; this has led to repeated questioning of the meaning and validity of the picture surface. In the cinema the techniques of stereoscopic film, cinemascope, cinerama and circularama are used in an attem to destroy this surface. In environmental art where the spectator's role is increasingly that of participant the picture surface has disappeared completely.

Long spectator distance and shallow field of focus

As an alternative to the use of multiple cones of vision, the effects of unwanted distortions resulting from the use of a very wide visual angle can be avoided by the use of a long spectator distance, a shallow field of focus, or both.

Caravaggio

There is a fine balance between monumentality and intimacy in Caravaggio's *The Supper at Emmaus* (fig. 58). The feeling of being a witness to an intimate event is brought about by such devices as the place at the table awaiting another chair; the fruit basket that may topple over; the chair on the left being informally cut off by the picture plane; and the painting of the life-size figures. On the other hand the breadth of handling, solidity and especially the minimal change of scale between one like form and another, combine to characterize the monumental qualities in this picture. For example, the outstretched hands of the disciple on Christ's left (presumably Peter) are nearly the same size even though he appears to be almost touching the picture plane with one hand, and the wall behind Christ with the other. Such minimal change of scale is only possible when the subject is viewed from a considerable distance, as in photography using a telephoto lens or as seen through a telescope, when the system approaches orthographic projection.

A central projection system has been used, yet only one true orthogonal is revealed, on the right-hand side of the table; this creates difficulties

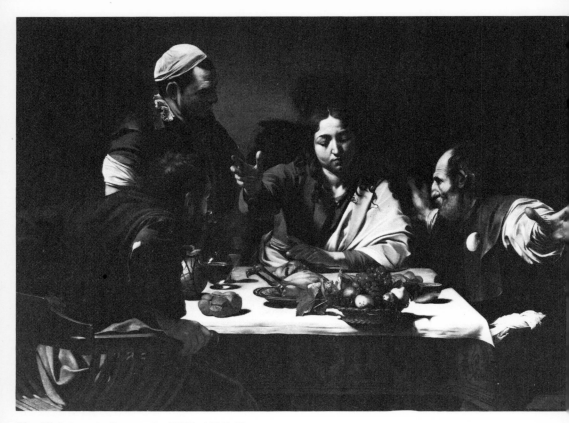

58 Michelangelo Caravaggio (1573–1610) *The Supper at Emmaus*. Oil on canvas 55 × 77 ½ in. (139 × 195 cm.). National Gallery, London

over discovering the exact position of the centre of vision. However, the bowl on the table can be 'crated' in order to make a square so that Leonardo's method may be applied. A very rough estimate using this method indicates that the spectator point is about seventeen feet (5 m.) from the picture plane (the size of the picture is 55 × 77 $\frac{1}{2}$ in. (139.7 × 196.9 cm.), giving a visual angle of about 22°).

The narrow depth of field, from the picture plane to the wall, and the relatively long spectator distance combined with the narrow visual angle overcome the difficulties associated with motion parallax that Caravaggio would have been aware of in painting a group of life-size figures. *The Supper at Emmaus* almost approaches Leonardo's ideas on simple perspective, where the subject is equally distant from the eye in every part.

Canaletto
Canaletto's first training was in his father's profession of scenography, and his *Feast Day of St Roch* (fig. 59) could be the setting for a theatrical performance staged on a grand scale in a great metropolitan opera house. The scene is typically Venetian, where the religious, social and commercial life is a public rather than a private affair, and is carried on in a sunlit square against the backdrop of a noble building. As in most of Canaletto's paintings the angle of vision here is wide, but he managed to avoid problems of distortion by confining the subject matter of the picture to the middle and far distance, and in this particular painting using a shallow field of focus. The effect of this can be seen towards the edges of the painting. The drawing of the little loggia (fig. 60) is virtually in oblique projection; if the orthogonals had noticeably converged then the distortion would have been disturbing. Canaletto's

59 Antonio Canaletto *Venice: the Feast of St Roch*
 c. 1727. Oil on canvas 58 1/8 × 78 1/2 in.
 (147.7 × 199.4 cm.). National Gallery, London

Opposite page:
60 Antonio Canaletto, drawing of the little loggia.
 Kupferstichkabinette, Berlin (West)

paintings display remarkable skill in topographical
draughtsmanship combined with a complete
understanding of the perspective devices that he
used with masterly assurance. This was an age
when perspective was studied with almost
passionate interest; Andrea Pozzo (who painted
the ceiling of the Jesuit church of St Ignazio in
Rome) published in 1707 a work on perspective

called *Perspectiva Pictorum* which was
translated into several languages and was a
source of inspiration to many artists including
Sir Joshua Reynolds.

 Throughout his life Canaletto's working me
varied; it is certain that he worked from drawi
made with the help of the camera obscura, as
well as painting on the spot.

81

61 Thomas Rowlandson *The Life Class in the Royal Academy Schools at Somerset House* 1811. Etching 5 ³/₄ × 8 ¹/₂ in. (14.6 × 21.6 cm.). Royal Academy, London

Rowlandson

The Royal Academy Schools, as we now know it, removed to Burlington House in 1869. Working presumably on the excellent principle 'finding something good and sticking to it', the drawing school is even now remarkably like the one shown in the engraving by Rowlandson, *The Life Class in the Royal Academy Schools Somerset House* (1811). The Somerset House School in its turn copied the design from Sir Thomas Thornhill's St Martin's Lane Academy.

The seating arrangements consist of a treble row of fixed benches forming a semicircle; at the centre of the arc is the model's throne. The daylight comes from one direction only, a most important amenity. Students who wish to draw

the full figure may sit 18 ft (6 m.) away from the model at the raised outer perimeter of benches, and those wishing to draw a seated figure or a detail sit at the lower inner perimeter. Thornhill was a painter who worked in, and thoroughly understood, the Grand European tradition, and in designing his drawing school he clearly had Leonardo's advice in mind: 'When you have to draw from nature, stand at a distance three times the size of the object you draw.'

When a standing figure is drawn at the Royal Academy Schools, the draughtsman sitting 18 ft (6 m.) away from the model, drawing board 18 to 20 in. (45.7 to 50.8 cm.) from his eyes and making the drawing sight size, the figure on the paper will measure from 6 to 8 in. (15.2 to 20.3 cm.) high. The draughtsman will then be taking advantage of the natural communication between eye and hand, drawing the size that he can see and consequently helping to avoid common difficulties like incorrect proportion, empty forms, and most of all multiple cones of vision.

The camera lucida

The camera lucida (fig. 62) was invented by William Hyde Wollaston in 1807, at a time when there was a decided movement in painting towards greater naturalism, and it was used by a number of artists including J. S. Cotman (fig. 63 *Scene in Normandy* 1823). The camera lucida achieves similar results to the camera obscura and has the advantage of being readily portable. In its little box it can be carried in a coat pocket, but it has the disadvantage of being tiresome to use as the spectator has to close one eye and keep the machine and the drawing board quite rigid.

The most important component is a four-sided prism, to which is attached a sighting

62

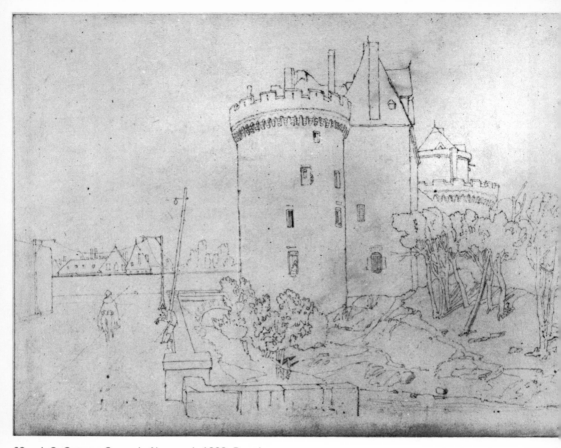

63 J. S. Cotman *Scene in Normandy* 1823. Drawing
9 × 11⁷/₈ in. (22.8 × 31 cm.). British Museum

device in the form of a piece of metal with a
small aperture. Between the prism and the pa
on the drawing board there is a lens which he
to bring the object and the paper on to the sa
apparent plane. The prism is held in a simple
casing open on two sides and attached to a p
of movable tubing, the other end being clamp
to a drawing board. The observer faces the
object he wishes to draw, having his drawing
board and camera lucida firmly fixed and the
drawing board lying parallel to the ground. H

then places his eye close to the aperture in the sighting device, which is adjusted so that half of the aperture reveals rays from the object through the prism, the other half revealing rays from the paper. The observer can see a deflected image of the view in front of him, apparently lying on the paper, at the same time seeing the tip of his pencil on the paper well enough for him to be able to copy the apparent image. The most complex topographical perspective view may be recorded with great accuracy. The size of the image depends on the spectator's distance from the paper, which is governed by the length of the movable metal tubing; drawings are therefore sight size. The visual angle is narrow, between $20°$ and $25°$.

David

The air of discontent in France in the late-eighteenth century which brought about a re-assessment of artistic, moral and political standards, culminated in the revolution of 1789 The painter Jacques Louis David was deeply involved in these events. In the eighteenth century, as the result of discoveries at Hercula-neum and Pompeii, the classical style in dress, furniture and decoration became fashionable. In painting the school of Neo-Classicism was born, with David at the head. In the painting *Madame Verniac* (fig. 64) the same perspective devices are used as in Caravaggio's *The Supper at Emmaus* — a long spectator distance, an extrem-ely narrow angle of vision and a shallow field of focus. Again the painting is monumental, but unlike *The Supper at Emmaus* the subject is formal and the paint dry and arid.

Napoleon embraced Neo-Classicism with enthusiasm and surrounded himself with furniture and trappings in this style; he also sat to David for a picture of himself crossing the Alps on a

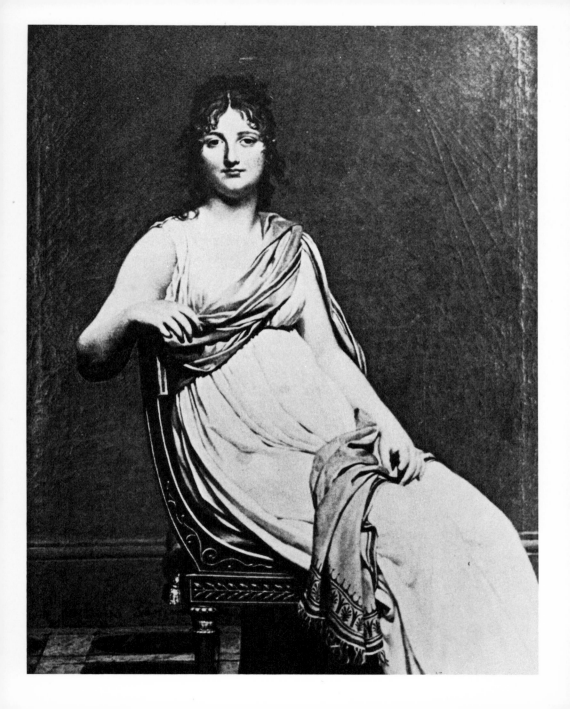

white charger: no doubt he relished the idea of a
parallel between himself and Hannibal.

David's pupil Ingres carried the Neo-Classical
tradition on into the nineteenth century, in
contrast to the romanticism of Delacroix and
Géricault who, like producers of cinema epics,
were constantly seeking to involve the spectator
intimately in stirring events.

During the nineteenth century artists working
in the classical tradition of David tended to move
the spectator further and further away from the
picture plane. The logical outcome of this was to
move the spectator to infinity (i.e. away from a
fixed spectator point) and to place all emphasis
on the surface of the picture. In 1912 Jacques
Rivière wrote a paper 'Present Tendencies in
Painting'; the following is an extract on why
perspective must be eliminated:

> . . . Perspective is as accidental a thing as
> lighting. It is the sign, not of a particular
> moment in time, but of a particular position in
> space. It indicates not the situation of the
> objects, but the situation of a spectator
> Hence, in the final analysis, perspective is also
> the sign of an instant, of the instant when a
> certain man is at a certain point. What is
> more, like lighting, it alters them – it dissi-
> mulates their true form. In fact, it is a law of
> optics – that is, a physical law
> Certainly reality shows us those objects
> multilated in this way. But in reality, we can
> change position: a step to the right and a step
> to the left complete our vision. The knowledge
> we have of an object is, as I said before, a
> complex sum of perceptions. The plastic image
> does not move: it must be complete at first
> sight; therefore it must renounce perspective.[1]

1. 'Sur les tendances actuelles de la peinture' *Revue
 d'Europe et d'Amerique,* Paris 1 March 1912,
 pp. 384–406.

Tone

The art historian Wolfflin made an important distinction between two ways in which a pain may perceive his subject; he called one way linear and the other painterly; these categories correspond fairly closely to the distinction we have made between conceptual and perceptua drawing systems.

Perceiving in a linear way is perhaps best exemplified by the Florentine painters of the fifteenth century who developed linear perspective. Drawings of this time are characte ized by the emphasis that is placed on the line aspect of design; in other words the edges of forms and shapes are emphasized; this general leads to great clarity of form, where each part a drawing is realized as something complete in itself.

The description 'painterly' is usually applied the Schools of Venice and the Netherlands and artists whom these schools have influenced. Equally the term may be applied to some perio of Chinese painting. The massing of areas of li and shade, the description of surfaces, the use painting media which will create atmospheric space; these are the marks of the painterly artis

For the uninitiated observer, sorting out the difference between the tones of various colour shade, shadows and reflected light, can be complicated to say the least. In classic nine- teenth-century art education, the study of tone and local colour was simplified for students by setting them the task of drawing from the 'whit world' of antique plaster casts. Students were able to observe the subtlest changes of light or

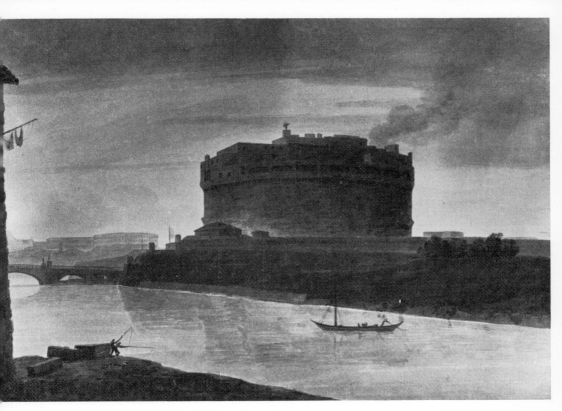

John Robert Cozens *View of the Castel Sant Angelo, Rome* 1780. Watercolour $14^3/_{16} \times 20^{11}/_{16}$ in. (36 × 52.5 cm.). Courtauld Institute, London

ɪ, the light source being usually high and
ɪing from the sunless north. When after such
ɔurse of study the students were able to judge
compare the value of one tone against
ther and to grasp the meaning of pure form,
y then graduated to the still life and life
ns, confident of being able to withstand the
uction of the local colour in a nude or an
e. Students were advised to screw up their
s and to look through their eyelashes to see
r subject in broad tonal terms. Fulfilling the
e purpose, a Claude glass was commonly

used by painters in the eighteenth and nine-
teenth centuries. This instrument is simply a
piece of glass blackened on one side, in which
the painter is able to see a simplified mirror image
of his subject against his own drawing or paint-
ing. The same effect is also observed in some
models of the camera obscura when the image
is seen through tracing paper on frosted glass.

Painters like John Robert Cozens (fig. 65)
who work directly from nature are able to record
their observations of tonal relationships and
atmospheric perspective on the spot. Painters

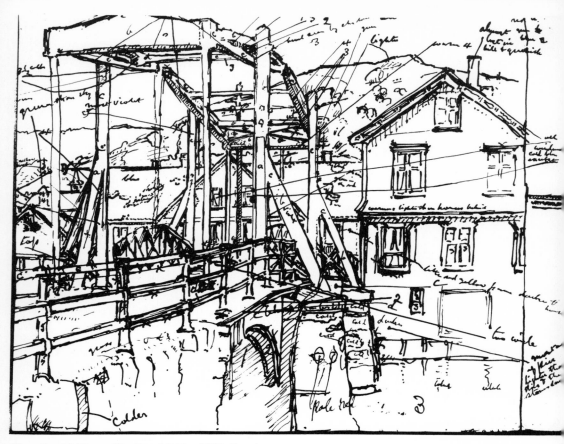

66a Harold Gilman *The Canal Bridge* 1913. Drawing
9 × 11½ in. (22.9 × 29.2 cm.). Tate Gallery,
London

who work away from their subject often have
private systems of their own for remembering c
recording their observations. Whistler, who had
an exquisite sense of tone, trained himself to
remember whole sequences of values, by
comparing each area of his subject value for
value against ready-made mixtures of grey.
Gwen John, who was for some time Whistler's
pupil, used a system of numbering tones. A
typical extract from her notes reads: 'road 32,
roof 13 to 23, grass 23, black coats 33, etc.'[1]
thus recalling that a part of a roof and the gras

1. *Gwen John: Retrospective Exhibition Catalogue,*
Arts Council 1968, Introduction by Mary Taubman.

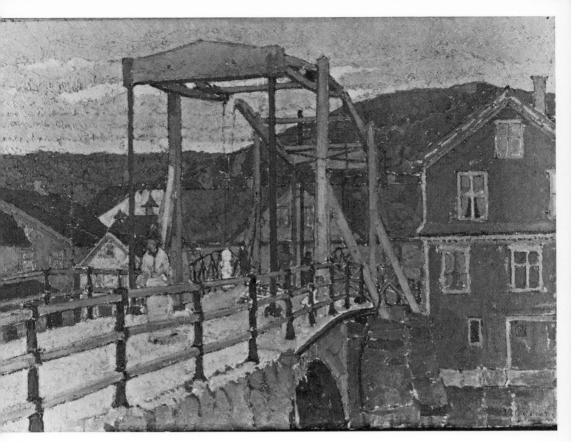

Harold Gilman *The Canal Bridge* 1913. Oil on canvas 18 × 24 in. (45.7 × 61 cm.). Tate Gallery, London

were of equal value and the road and black coats were very nearly equal. Harold Gilman used letters, numbers and written colour notes in his drawings (figs 66a and 66b); the meaning is decipherable when one can compare the drawing and painting side by side. The same technique can be used in computer graphics in applications such as hill shading where a range of tones is defined according to a numbered scale. Clearly the system of painting by numbers has had some distinguished practitioners.

Mixed systems

Sometimes two or more drawing systems are used within the same composition – either deliberately or due to the collision of different cultures.

Perspective/oblique projection: Giotto

There is in Giotto's earlier paintings a persistent use of oblique projection as an alternative to perspective. It is of course possible that this was accidental, but it has been suggested[1] that the use of two different systems was deliberate, and was a pictorial device to describe two different kinds of space; heaven and earth. In the *Vision of the Thrones* (fig. 31), the thrones at the top of the picture are in strict oblique projection; the orthogonals lie at 45°, and are perhaps intended to be true lengths. At the bottom of the picture, on earth, the altar is far from perfect; although the orthogonals converge in the vertical direction, in the horizontal direction they are parallel, or even diverge, and the two columns which support the canopy are spatially contradictory.

In addition to this painting, and the *Crucifix at San Damiano*, two other paintings definitely by Giotto, *The Saint sees a Building in a Dream*, and the *Vision of the Fiery Chariot*, as well as the *Apparition to Fra Agostino and the Bishop* (perhaps by Giotto), show the use of two different projection systems within the same picture, and in all of them the subject of the picture is a 'vision', i.e. the simultaneous concurrence of two different kinds of space.

Dante used a similar device in the last stanza of *The Divine Comedy* (written about twenty years after Giotto had finished painting at Assisi) to describe his final vision of heaven:

Nella profunda e chiara sussistenza
Dell'alto lume parvenitre giri
Di tre colori e d'una contenenza.

That light supreme, with its fathomless
Clear substance, showed to me three spheres
which b
Three hues distinct, and occupied one space

If this use of oblique projection and perspective as alternative systems was intentional, then Gio was not only the first artist to make a deliberate compositional use of space within the painting rather then on the surface, but also the first arti to use mixed systems expressively.

Vertical oblique/orthographic/schematic: Juan Gris

'Pictorial Mathematics leads me to the physical representation' – Juan Gris 1923.

If we disregard for the moment the use of colou and tone in the painting (fig. 67), and consider only the form, it becomes apparent that the tabl and the two cups and the glass standing on it, are in straightforward vertical oblique projection (fig. 68). If this were all, these objects would appear quite solid, but the Cubists were most

1. John White op. cit. p. 33.

2. Dante *Paradise* translated by Dorothy L. Sayers and Barbara Reynolds, Penguin Books: London 1962.